POSTCARD HISTORY SERIES

Baltimore Neighborhoods

POSTCARD HISTORY SERIES

Baltimore Neighborhoods

Marsha Wight Wise

ARCADIA
PUBLISHING

Published by Arcadia Publishing
Charleston, South Carolina

Printed in the United States of America

Library of Congress Control Number: 2007928179

For all general information contact Arcadia Publishing at:
Telephone 843-853-2070
Fax 843-853-0044
E-mail sales@arcadiapublishing.com
For customer service and orders:
Toll-Free 1-888-313-2665

Visit us on the Internet at www.arcadiapublishing.com

*To William Hollifield for the generosity of his collection,
his vast knowledge of all things Maryland, and his friendship.*

CONTENTS

ACKNOWLEDGMENTS

There are three men without whose help this book would not be in your hands. First, I would like to thank William Hollifield for opening up his vast collection. His generosity goes beyond just me. He appreciates having the opportunity to share his collection with the public. Second, I would like to thank Francis O'Neill, senior librarian at the H. Furlong Baldwin Library of the Maryland Historical Society. Without his endless knowledge of Baltimore history, Sanborne Maps (which he says would be the first thing he would grab in the event of a fire), and Baltimore City Directories, much detail would be missing. Francis is the heart and soul of the library. Last but most certainly not least, I need to thank my husband, John Wise. Without his support and help, I could have never finished this book. He is, without a doubt, my knight in shining armor.

To the best of my ability, I have attempted to ensure accuracy given the antiquated and, often, obscure nature of the subject matter and materials.

The images in this volume appear courtesy of the postcard collection of William Hollifield (WH) and the author's personal collection (MWW).

REFERENCES

Bowditch, Eden Unger. *Growing Up in Baltimore: A Photographic History*. Charleston, SC: Arcadia Publishing, 2001.

Brain, John. *Govans Village and Suburb*. Baltimore, MD: Uptown Press, 1996.

Dielhman-Hayward Obituary Files, Maryland Historical Society.

Dorsey, John, and James D. Dilts. *A Guide to Baltimore Architecture*. Centreville, MD: Tidewater Publishers, 1981.

Giza, Joanne, and Catherine F. Black. *Great Baltimore Houses: An Architectural and Social History*. Baltimore, MD: Maclay and Associates, Inc., 1982.

Hayward, Mary Ellen, and Charles Balfoure. *The Baltimore Rowhouse*. New York: Princeton Architectural Press, 2001.

Headley, Robert K. *Motion Picture Exhibition in Baltimore: An Illustrated History and Directory of Theaters, 1895–2004*. Jefferson, NC: McFarland and Company, 2006.

Higham, Eileen. *Tuscany-Canterbury: A Baltimore Neighborhood History*. Baltimore, MD: Maryland Historical Society, 2004.

Latrobe, John H. B. *Baltimore's Monuments and Memorials*. Baltimore, MD: self-published, 1995.

www.LiveBaltimore.com.

Pasano Historical Structures Files, Maryland Historical Society.

Scharf, J. Thomas. *Chronicles of Baltimore*. Baltimore, MD: Turnbull Brothers, 1874.

———. *History of Baltimore City and County*. Baltimore, MD: Regional Publishing Company, 1971, reprinted from 1881.

Wilson, Jane Bromley. *The Very Quiet Baltimoreans: A Guide to the Historic Cemeteries and Burial Sites of Baltimore*. Shippensburg, PA: This White Mane Publishing Company, 1991.

INTRODUCTION

Dear Reader,

I have always loved a good mystery. Little did I realize how many mysteries I would be solving in the process of researching this book. I thought a pictorial history book about Baltimore, as depicted in vintage postcards, would be easy. I was greatly mistaken. I thought I knew a lot about Baltimore and was quickly humbled when I began my research. It is my intention that this book be more than a visual connection with Baltimore. Rather, I want you to come away saying, "I didn't know that." For the last six months, I have said that to myself almost daily. Giving narrative to the images between these pages was painstaking but well worth the effort. Some subjects were easy if they were well-established institutions such as churches or schools. The postcards that interested me the most, however, were the more obscure ones. Sometimes I just had a business or individual's name to work with. Other times, I was enlarging the image by 175 percent on my computer so that I could decipher a street sign. When discussing this book with others, I heard a few comments of "another postcard book?" I think, reader, that you will find this book contains more detail than any other Baltimore-based postcard book before it.

One of the dilemmas in writing this book was how to organize it. I needed a definitive point of reference. I found such a reference at the LiveBaltimore.org Web site. Live Baltimore is an online resource center for city living. Their maps and neighborhood definitions were invaluable. I chose to reference a neighborhood as it is known today so that you may relate more easily to the locations. Where applicable, I have included Web addresses so that you can further explore a subject if you wish.

Not all neighborhoods are represented here, and if your neighborhood isn't, please do not feel slighted. I was only able to include neighborhoods that I found depicted in vintage postcards. Space may have also been a contributing factor of any omissions.

I hope that you enjoy reading this book as much as I enjoyed writing it. There is a little bit of my own personal history included here. I begin the book with my alma mater, Seton High School. I will confess that I may have given a little more space than necessary to South Baltimore and Federal Hill. I spent the first 29 years of my life in those neighborhoods—call it poetic license. I regretted not having but two postcards to depict my current neighborhood of Hunting Ridge. I hope you find some of your own history written here. I'd love to hear your story sometime.

Please join me on the Web at www.marshawightwise.com.

—Marsha Wight Wise
Hunting Ridge
November 2008

FOREWORD

Many of the postcards illustrated in this book are from my collection. I have been acquiring them since the 1970s, and my collection may be among the most extensive collections of early postcards of Maryland, or at least cards of central Maryland.

Collecting postcards was very popular in the early years of the 20th century. People could obtain them for 1¢ and mail them anywhere in the country for just 1¢ more. Clubs were formed in which people mailed cards from their own towns to fellow collectors in other cities and towns. Later, however, for a long time, interest in these postcards declined considerably, and the few who wanted them could buy a shoebox full of them for just a few dollars. More recently, however, there has been a considerable interest, and the old postcards are eagerly sought by new generations. The difference is that initially people were saving cards showing contemporary views and now people are looking for cards because of their historic interest. The postcard collectors of the early 20th century would have been surprised if they could have known that the cards readily available to them for a few cents would be, a century later, eagerly sought after as objects of local history.

When I began searching for early Maryland postcards, most of them could be obtained for 10 to 50¢ each. A dollar was considered expensive then, but now it is reasonable, with many of the more desirable cards selling for as much as $20 to $30. Earlier there was little distinction between postcards that were printed and those that were photographs (referred to as real-photo postcards). The photographic cards have become especially sought after and expensive.

As with anything that is collected, you eventually realize which are the most common items and hope to find those that are unusual. In addition to the cards that are actual photographs, the more desirable ones are those depicting small towns, suburban communities, and obscure churches, schools, stores, and movie theaters.

Many of the cards illustrated here are especially desirable because they show what some of the Baltimore suburban areas were like in the early to mid–20th century. Some of them are rare because they were probably produced in small quantities and few have survived to the present.

I am pleased that some of the cards in my collection can be made available to the public through publications such as this one.

—William Hollifield

One

THE NORTH

CHARLES VILLAGE, GOVANS, GUILFORD, HAMPDEN, HOMEWOOD, MOUNT WASHINGTON, ROLAND PARK, TUSCANY/CANTERBURY, WAVERLY, WYMAN PARK

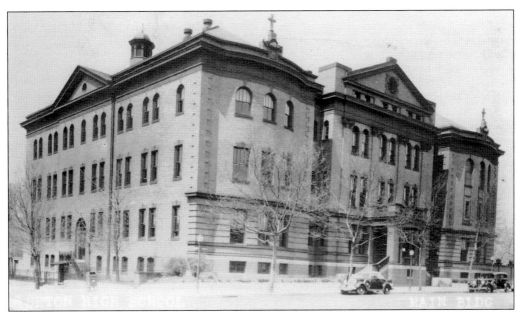

SETON HIGH SCHOOL, 2800 NORTH CHARLES STREET (CHARLES VILLAGE). Seton High School, alma mater of the author, began in 1865 as the St. Joseph School of Industry at Carey and Lexington Streets. The Daughters of Charity, founded by St. Elizabeth Anne Seton, opened the first school for girls, which taught trades such as dressmaking, stenography, and typing. In 1907, the school moved to the North Charles Street location. In 1926, the name was changed to Seton High School and the curriculum refocused on an academic and business program. In 1988, the school merged with Archbishop Keough High School and moved to its West Baltimore campus. The building is now owned by Johns Hopkins University. (WH.)

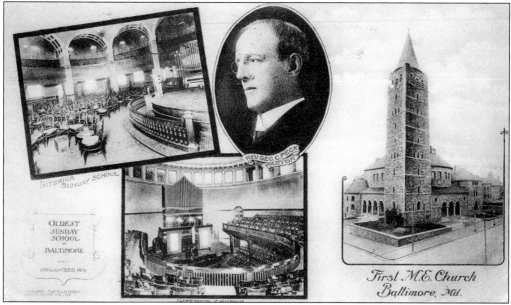

FIRST M. E. CHURCH, 2200 ST. PAUL STREET, POSTMARKED 1921 (CHARLES VILLAGE). The church was designed by Stanford White in 1884 as a centennial monument to the founding of the Methodist Episcopal Church. White borrowed architectural elements from churches in Ravenna, Italy. Now Lovely Lane United Methodist Church, the building is on the National Register of Historic Places. The artifacts and archives of the American Methodist Historical Society are housed at the church and are open to the public (www.lovelylanemuseum.com). (WH.)

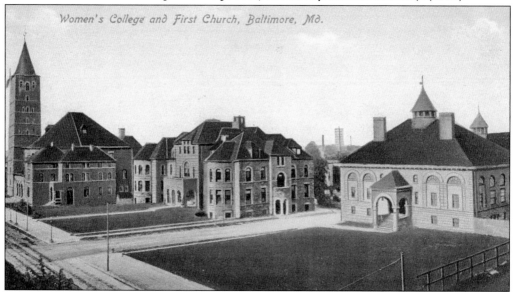

WOMEN'S COLLEGE OF BALTIMORE, 2220 ST. PAUL STREET (CHARLES VILLAGE). The college was founded in 1885 by John Franklin Goucher, a Methodist minister. The school was completed in 1888 on land donated by Reverend and Mrs. Goucher. The college opened with 140 students, who paid a $100 tuition. Before that time, there were no colleges in the state of Maryland dedicated to educating women. In 1909, the school changed its name to Goucher College to reflect that of its benefactor. (MWW.)

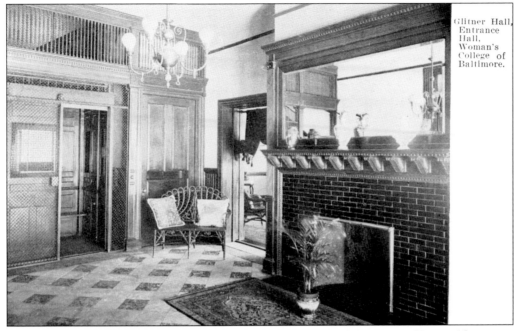

WOMEN'S COLLEGE OF BALTIMORE, GLITNER HALL ENTRANCE HALL (CHARLES VILLAGE). The college provided dormitory accommodations for its non-local students. Glitner Hall, as seen here, provided the girls with a homey, elegant environment. The curriculum offered four courses of study: classical, modern languages, natural science, and mathematical. In addition, art, music, and elocution were offered to ensure the girls were prepared to take their place in polite society. (WH.)

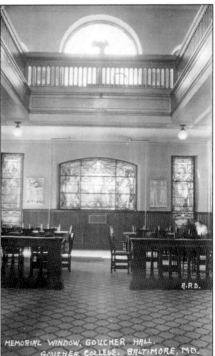

GOUCHER COLLEGE, GOUCHER HALL MEMORIAL WINDOW (CHARLES VILLAGE). By 1908, the college had three buildings, including a gymnasium considered one of the best in the country. In the 1920s, the college had outgrown its St. Paul Street campus and purchased 421 acres in Towson. The Great Depression set the school back financially, and the new campus was not completed until 1955. Today Goucher College is coed and has a student population of over 1,700 (www.goucher.edu). (WH.)

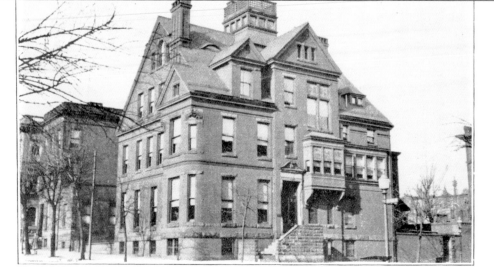

Beck's Diagnostic Clinic. St. Paul and Twenty-third Streets, Baltimore

BECK'S DIAGNOSTIC CLINIC, ST. PAUL AND TWENTY-THIRD STREETS (CHARLES VILLAGE). Originally a private residence, the home was built in 1886 for James E. Hooper (1839–1908), a textile mill owner in nearby Hampden. The home was most likely designed by Goucher College's architect, Charles L. Carson. Adorned with massive amounts of oak paneling, the home contained the city's largest pier mirror (11 by 6 feet) on the second-floor landing. Hopper launched the Maryland chapter of the Automobile Association of America (AAA) in his home. (WH.)

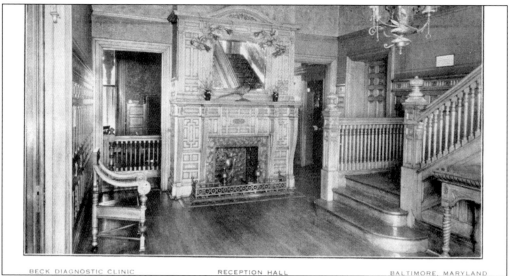

BECK'S DIAGNOSTIC CLINIC RECEPTION HALL, ST. PAUL AND TWENTY-THIRD STREETS (CHARLES VILLAGE). In 1921, a few years after his death, Hooper's daughter sold the house to Dr. Harvey Grant Beck (1870–1951). Dr. Grant was a specialist in internal medicine who operated a 14-bed private clinic there for 26 years. Beck left the house to the Baptist Association of Maryland, who occupied it until 1980. Other occupants included the Red Cross and the Big Brother Big Sister headquarters. Today it is owned and occupied by Morphius Records. (WH.)

12

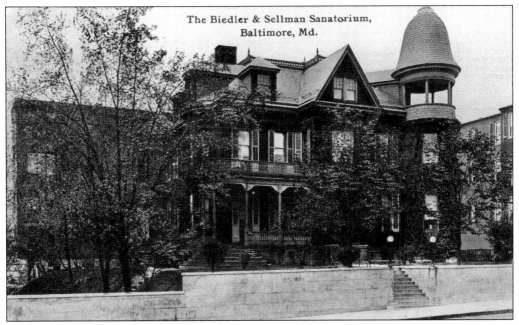

The Biedler & Sellman Sanatorium, Baltimore, Md.

THE BIEDLER AND SELLMAN SANATORIUM, 2714–2728 NORTH CHARLES STREET (CHARLES VILLAGE). Built in 1891 for Franklin J. Morton, organizer of Baltimore's Crown Cork and Seal Corporation, the home was known as Duanallyn. Around 1900, the home was sold to Dr. James Barnard, who converted it into a sanitarium. From 1922 to 1927, it was the Homewood Hospital. In 1940, the mansion was torn down, and the hospital that stands today is the Future Care Homewood Center. (WH.)

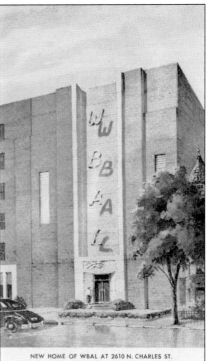

NEW HOME OF WBAL AT 2610 N. CHARLES ST.

THE NEW HOME OF WBAL, 2610 NORTH CHARLES STREET (CHARLES VILLAGE). On March 11, 1948, WBAL-TV broadcasted to Baltimore viewers for the first time. Viewers enjoyed a variety of programs—in between frequent test patterns—including *Musical Almanac, Look and Cook, Know Baltimore,* and Western films. WBAL-TV also offered news and sports reporting and was the first to bring color television to Baltimore. In the 1950s, WBAL-TV gave its viewers *Romper Room,* Baltimore's first live morning variety show for children. The show eventually became an internationally syndicated program (www.wbaltv.com). (WH.)

13

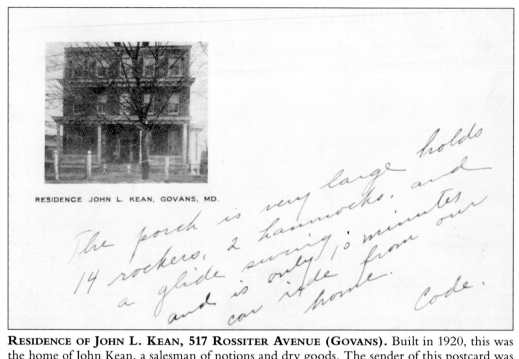

RESIDENCE JOHN L. KEAN, GOVANS, MD.

The porch is very large holds 14 rockers, 2 hammocks, and a glide swing is only 10 minutes car ride from our home. Code.

RESIDENCE OF JOHN L. KEAN, 517 ROSSITER AVENUE (GOVANS). Built in 1920, this was the home of John Kean, a salesman of notions and dry goods. The sender of this postcard was very taken with the front porch—"The porch is very large holds 14 rockers, 2 hammocks, and a glide swing and is only 10 minutes car ride from our home." The home still stands and remains a private residence. (WH.)

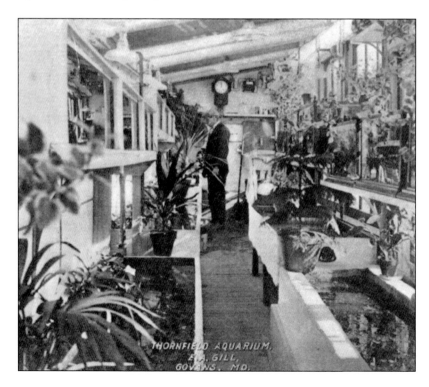

THORNFIELD AQUARIUM, E. A. GILL (GOVANS). Dated around 1915, this card depicts a young man among tanks of fish and aquatic plants. With the last name of Gill, it was only fitting that he would go into the aquarium business. This is possibly World War II colonel Edward A. Gill, who died in action in France in 1944. (WH.)

14

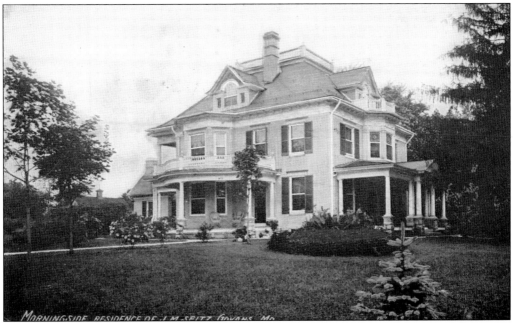

MORNINGSIDE, RESIDENCE OF JAMES M. SEITZ, 6300 YORK ROAD (GOVANS). James M. Seitz (1856–1940) was an authority on refrigeration engineering when the field was still in its infancy. He was one of the incorporators of the Independent Ice Company and the City Ice Company. The house has been razed. In its place stands a Rite-Aid Drug Store. (WH.)

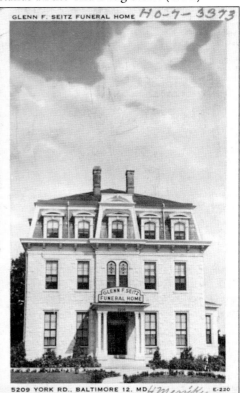

GLENN F. SEITZ FUNERAL HOME, 5209 YORK ROAD (GOVANS). One of the last large homes in Govans to survive is the McCabe Mansion, built by Col. Lawrence McCabe around 1850. McCabe was a noted construction engineer. He was the engineer of the Holland Tunnel in New York. The project lost so much money that McCabe had to sell his home and move into a cottage across the street. In 1950, Glenn Seitz purchased the home and converted it into a funeral home. (WH.)

15

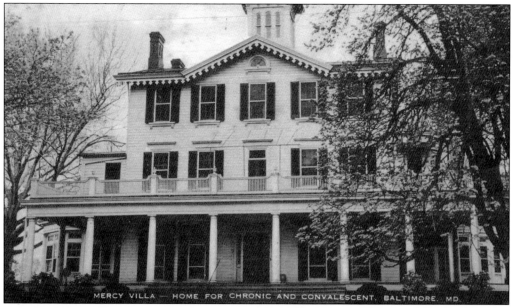

MERCY VILLA — HOME FOR CHRONIC AND CONVALESCENT. BALTIMORE. MD.

MERCY VILLA—HOME FOR CHRONIC AND CONVALESCENT, 6806 BELLONA AVENUE.
This Italianate mansion was built in 1865 for tobacco dealer J. Hall Pleasants (1822–1901) and known as Cherry Lawn. In 1893, the home and its surrounding 27 acres were sold to William Lanahan (1849–1912), who changed the name to Beaumont and later to Blenheim. Mrs. Blenheim (Catherine Carroll, a descendant of Charles Carroll of Carrollton) died in 1920, leaving the house to the Sisters of Mercy, who turned it into the home. The sisters sold the house in 1973. (WH.)

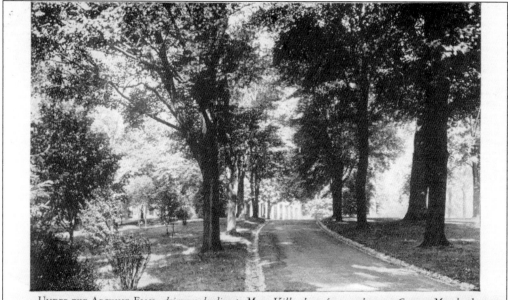

UNDER THE ARCHING ELMS--driveway leading to Mercy Villa, home for convalescents, Govans, Maryland

UNDER THE ARCHING ELMS—DRIVEWAY TO MERCY VILLA. The reverse reads, "During the period following illness, the patient requires rest, comfort, and nourishing food. Mercy Villa offers these and the ministrations of the Sister of Mercy to the convalescent." (WH.)

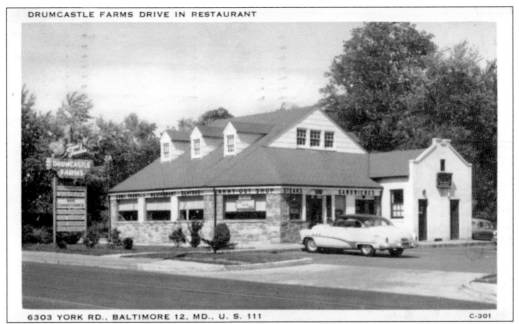

DRUMCASTLE FARMS DRIVE-IN RESTAURANT

6303 YORK RD., BALTIMORE 12, MD., U. S. 111 C-301

DRUMCASTLE FARMS DRIVE-IN RESTAURANT, 6303 YORK ROAD, POSTMARKED 1952 (GOVANS). The diner was located on the former pre–Civil War estate of the Walker family known as Drumquhazel. The reverse reads, "Curb, Counter or Dining Room—Dinner, Lunch or A Snack—We Serve the Best from "Soup to Nuts"—That's Why They All Come Back!—Hamburgers—Triple Thick Milk Shakes—Delvale Ice Cream—Full Course Meals—Sandwiches—Curb Service." The restaurant no longer stands. In its place is a gas station. (WH.)

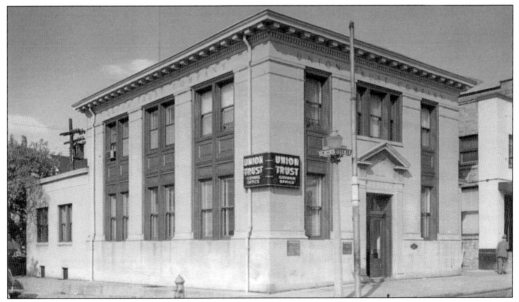

UNION TRUST BANK, GOVANS BRANCH, 5300 YORK ROAD (GOVANS). Constructed in 1900, the Union Trust Bank occupied the building at the corner of York Road and Homeland Avenue. In 2002, it became home to the Antioch Church Home and Shelter. (WH.)

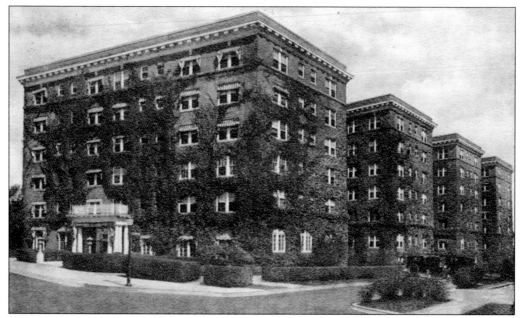

GREENWAY APARTMENTS, POSTMARKED 1937 (GUILFORD). The Greenway Apartment building is located on Greenway, near Johns Hopkins University. In 1963, the university purchased the building during a housing shortage to increase enrollment. In 1965, the building was renamed McCoy Hall in honor of John W. McCoy, a wealthy Baltimore merchant. Upon his death in 1889, McCoy left the university his 8,000-volume library, his house, and approximately half a million dollars, the largest gift since Johns Hopkins's original bequest. (WH.)

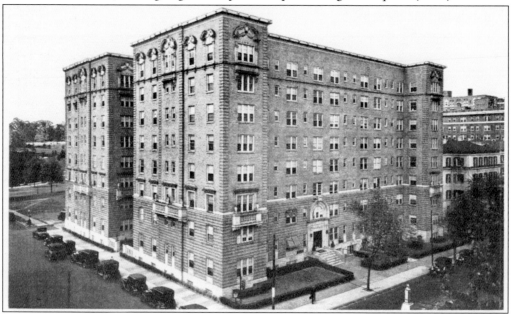

THE HOPKINS APARTMENTS, 3100 ST. PAUL STREET (GUILFORD). The reverse reads, "The Hopkins offers Baltimoreans modern, comfortably planned apartments of all sizes; Located at 3100 St. Paul Street in exclusive North Baltimore, the Hopkins also assures the best in shopping and transportation conveniences." (WH.)

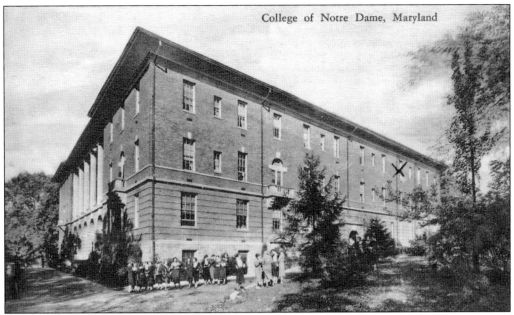

College of Notre Dame, Maryland

COLLEGE OF NOTRE DAME OF MARYLAND, 4701 NORTH CHARLES STREET, POSTMARKED 1942 (GUILFORD). Notre Dame College, as it was originally called, was founded in 1873 by the School Sisters of Notre Dame for education of young women. In 1896, the college became the first Catholic women's college in the United States chartered to offer bachelor of arts degrees. (WH.)

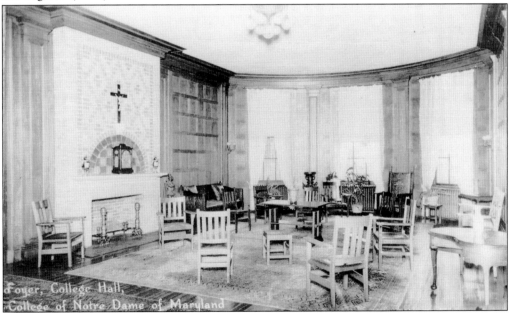

COLLEGE OF NOTRE DAME OF MARYLAND, COLLEGE HALL FOYER (GUILFORD). Gibbons Hall was the first building on the campus, constructed in 1893. The college's Marikle Chapel of the Annunciation, originally designed by Baldwin and Pennington, was restored in 2002. Other buildings of note are Fourier Hall, a stunning example of art moderne architecture, and Noyes Alumnae House, built in the 1840s (www.ndm.edu). (WH.)

RED CROSS INSTITUTE FOR THE BLIND (GUILFORD). The Red Cross Institute for the Blind was organized in 1917. The beautiful residence, known as Evergreen Junior, had extensive grounds located on Cold Spring Lane between North Charles Street and York Road. It was loaned to the government by Mrs. T. Harrison Garrett, to be used for the reeducation of blind soldiers, sailors, and marines. (WH.)

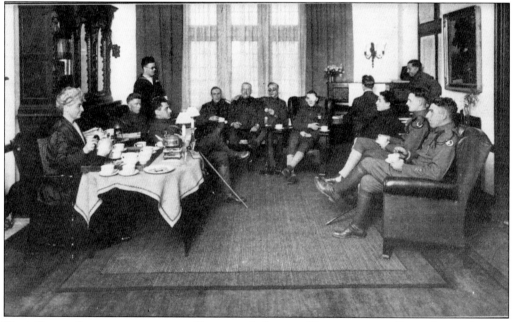

RED CROSS INSTITUTE FOR THE BLIND—A SOCIAL HOUR AT THE RED CROSS HOUSE (GUILFORD). The reverse of the card reads, "As soon as the first men came to Evergreen from overseas, they found the American Red Cross maintaining a beautiful club-house for their education and entertainment. In the winter, when the school sessions are over in the afternoon, students and teachers always find someone ready to receive them at the Red Cross House." The institute received visits from dignitaries, including Queen Elizabeth of Belgium and Helen Keller. (WH.)

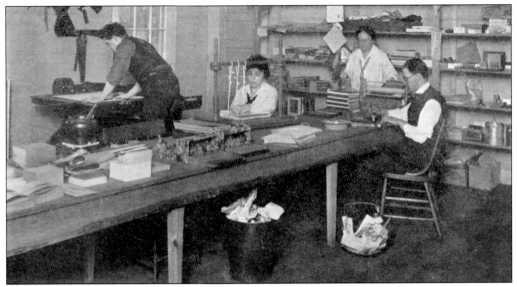

RED CROSS INSTITUTE FOR THE BLIND—BOOKBINDERS (GUILFORD). The reverse of this card reads, "Bookbinding offers a splendid form of finger training for the men, and while not many are likely to enter this profession, the handling of small objects in the making of boxes, index files, as well as the binding of books, has proved to be an excellent industrial activity." Other skills were taught such as typewriting, Braille reading, Dictaphone, machining, vulcanizing, poultry and dairy farming, salesmanship, and massage. (WH.)

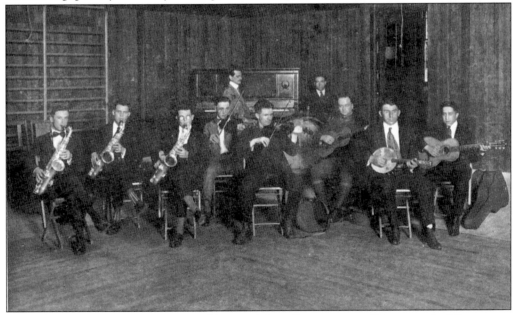

RED CROSS INSTITUTE FOR THE BLIND—THE ORCHESTRA (GUILFORD). The reverse of the card reads, "Almost all the men enjoy music. It is an excellent form of diversion. An opportunity is given every man to receive instruction on whatever form of musical instruction he may desire to play." The school closed around 1925, and the property was returned to the Garrett family. Many of the institute's buildings were razed, and others would be used by Loyola College when developing their campus in the early 1920s. (WH.)

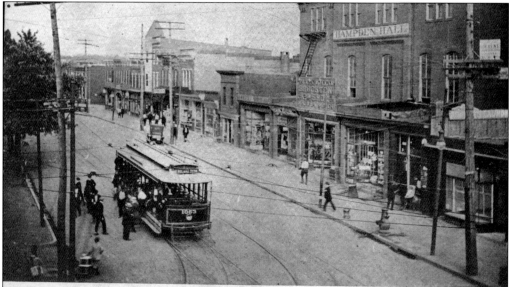

Compliments of The Harris Press, Printers.　　　　　Business Section, West 36th Street, Hampden, Baltimore, M

BUSINESS SECTION, WEST THIRTY-SIXTH STREET (HAMPDEN). This block of Thirty-sixth Street is better known to locals as "the Avenue" and is still very much a bustling business district, as it was when this photograph was taken. Today one will find antique shops alongside kitschy clothing stores. The street is home to the annual "Hon Fest," which takes place during the second weekend in June (www.hampdenmainstreet.org). (WH.)

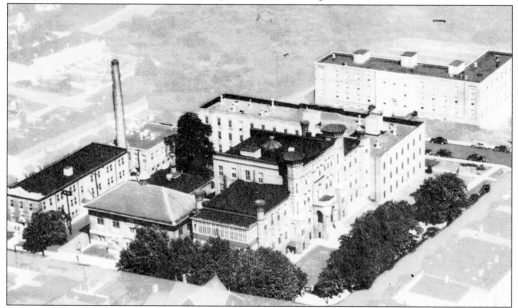

HOME FOR INCURABLES, BAURENSCHMIDT BUILDING AND DUNNING AUDITORIUM, KESWICK ROAD AND FORTIETH STREET. Built in 1906, it was originally the Egenton Home for Girls, which supported white female orphan children. By 1925, the campus was too small and the home moved to 1017 St. George Road. Later the property became the Keswick Home and Hospital. Today Keswick Multi-Care Center occupies the location, but all of the original buildings have been replaced. (WH.)

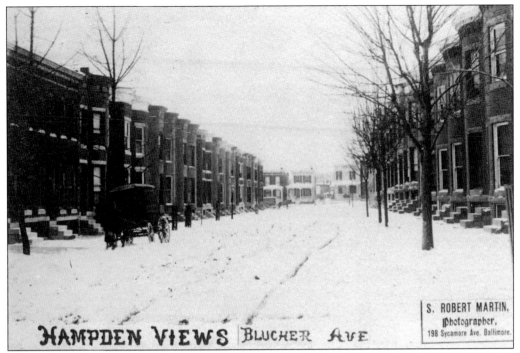

BLUCHER AVENUE, C. 1900 (HAMPDEN). The row houses on Blucher Avenue, known today as Wellington Street, were built sometime around 1898. The street's name change occurred during World War I when Baltimore de-Germanized many of its street names. Blucher was the name of Prussian Marshall Gebhard Leberecht von Blucher. He fought with the Duke of Wellington at Waterloo, thus the name change. (WH.)

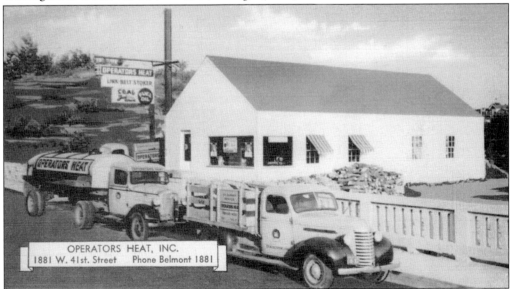

OPERATORS HEAT, INC., 1881 WEST FORTY-SECOND STREET (HAMPDEN). The reverse reads, "Our new and enlarged office three blocks west of Falls Road where the Crosstown bus stops in front of the door. Here are a few of the trucks which are waiting to serve you—Please come and see us." (WH.)

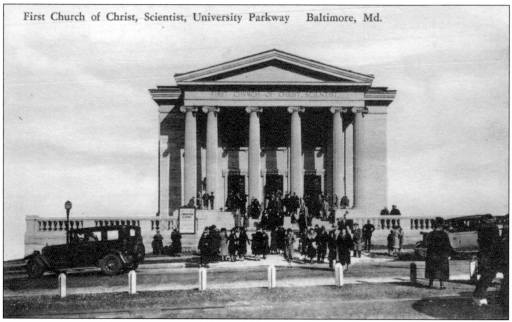

First Church of Christ, Scientist, University Parkway Baltimore, Md.

FIRST CHURCH OF CHRIST, SCIENTIST, 102 WEST UNIVERSITY PARKWAY (HOMEWOOD). Built in 1913, the church was designed by noted Baltimore architect Charles E. Cassell. The church is made of marble and terra cotta in a classical revival style. In 1982, it was added to the National Register of Historic Places. (WH.)

K. KATZ AND SONS, NORTHWOOD SHOPPING CENTER (NORTHWOOD). Northwood Shopping Center was built in the 1930s and was one of the first strip shopping centers in Baltimore City. Today the shopping center is vacant and is owned by Morgan State University. K. Katz and Sons was owned by Meier Katz, father of Hilda Katz Blaustein. Hilda was wife of Jacob Blaustein, son of the founder of American Oil Company (AMOCO). The Blausteins' endowment and creation of the Blaustein Foundation has benefited Baltimore greatly. (WH.)

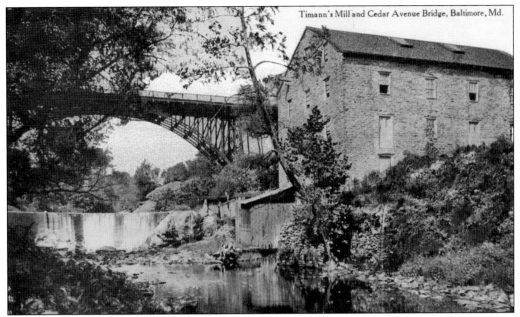

TIMANUS' MILL AND CEDAR AVENUE BRIDGE (REMMINGTON). Originally named Hollingsworth's Mill, the *c.* 1802 stone building was constructed by James Hughes. In 1861, it was purchased by John T. Timanus (1824–1879), father of an 1890s Baltimore mayor. Baltimore's city directories list the family firm, D. C. Timanus and Brother, as operating the mill through 1927. It was torn down in the 1930s. Only the milldam on the Jones Falls and a pile of rubble under the Cedar Avenue Bridge mark its site today. (WH.)

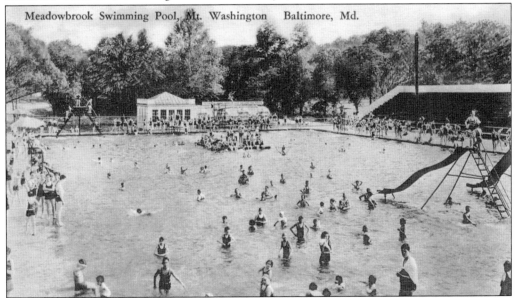

MEADOWBROOK SWIMMING POOL, 5700 COTTONWOOD AVENUE (MOUNT WASHINGTON). The original pool seen here was built in 1930 by the George Morris Company. Meadowbrook's main pool was excavated using mule-drawn shovels. The swim facility has seen many changes over the years through fire and renovations. The 1995 indoor aquatic center is where Olympic gold medalist and current owner Michael Phelps trained as a child (www.mbrook.com). (WH.)

25

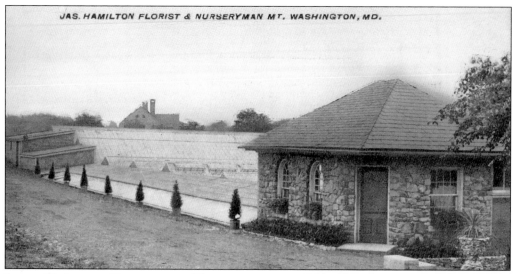

JAMES HAMILTON FLORIST AND NURSERYMAN, C. 1911, 1900 BLOCK OF GREENBERRY ROAD (MOUNT WASHINGTON). James Hamilton (about 1859–1938) was a descendant of the Marquis and first Duke of Hamilton, of Strathhaven, Scotland. His father purchased the 87-acre estate in 1803 and ran a lumber mill there, specializing in imported Honduras woods, until the end of the Civil War. Hamilton, like his father, raised flowers as a hobby that later developed into a lucrative floral business. In 1892, he was elected a member of the House of Delegates from the Mount Washington area when it was then part of Baltimore County. Condominiums now occupy the land. (WH.)

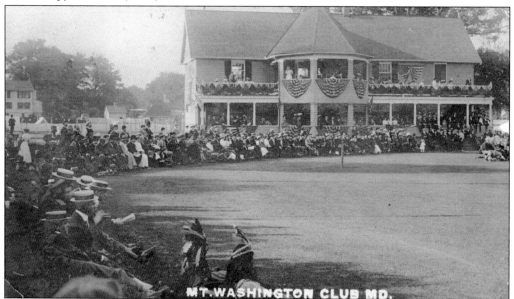

MOUNT WASHINGTON CLUB, POSTMARK 1909 (MOUNT WASHINGTON). The club was built in 1904 by the Mount Washington Cricket Company on land purchased from the Baltimore Cricket Club. The club was razed to make room for the Jones Falls Expressway. A new facility was built on Cottonwood Avenue. Note the American Indian headdresses being worn in the foreground of this photograph. Perhaps they were team mascots of one of the cricket teams playing that day. (WH.)

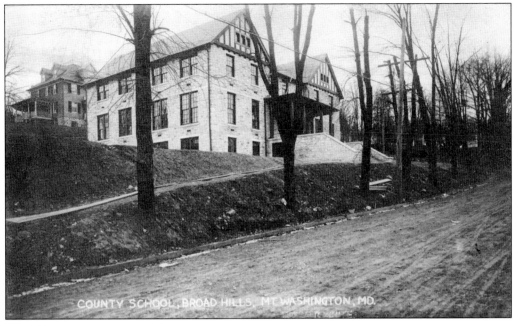

COUNTY SCHOOL NO. 221, BROAD HILLS (MOUNT WASHINGTON). The school was originally built as a community meeting hall in 1867 at 1619–1621 Sulgrave Avenue. A local schoolteacher convinced the community that Mount Washington needed a school more than a meeting hall and the building was repurposed. The school was razed in 1961. (WH.)

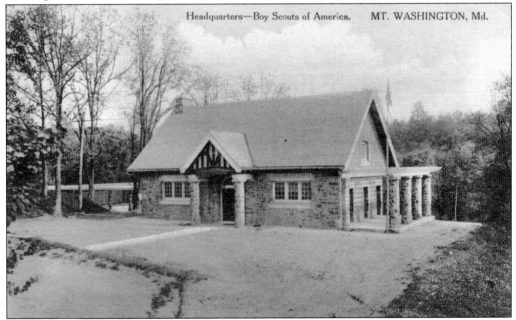

HEADQUARTERS BOY SCOUTS OF AMERICA (MOUNT WASHINGTON). The Boy Scouts of America (founded in 1910) regional headquarters was built in 1912 and dedicated to then current Maryland governor Phillips Lee Goldsborough (1865–1946). The building was abandoned and allowed to decay after the council moved to its current location on Wyman Park Drive. In the 1960s, the ruins were cleaned and the land declared a historical site. (WH.)

215 Longwood Road (Roland Park). This stucco home was built in 1913 by Dr. Paul Haupt (1858–1926), who was a professor of Semitic languages and director of the Oriental Seminary at Johns Hopkins University. Born in Germany, he was a Hebrew scholar and American delegate to numerous international education conventions and recognized as one of the leading philologists of the world. The home still stands and remains a private residence. (WH.)

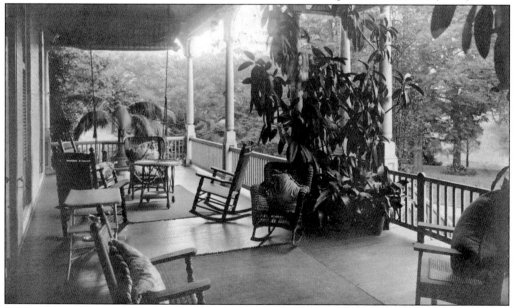

312 Forest Road (Roland Park). This was the home of Charles (1859–1931) and Nellie (born 1864) Coggins. Charles Coggins was the manager of the Millers Safe Company. He resided here with his children, F. Heath (1887–1984), Lillie (born 1891), and Alice (born 1896). As an adult, in 1906, Heath (who outlived three wives) founded and ran for 70 years what was then the Roland Park Blue Book; later he would expand it to include Guildford and Homeland. (WH.)

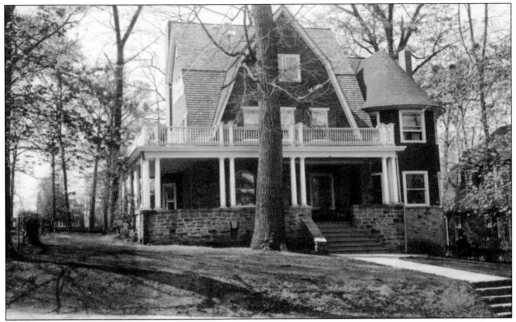

508 WOODLAWN ROAD (ROLAND PARK). This unique home was built in 1898 and spent most of its early days as a boardinghouse. In 1935, the house was purchased by Dr. Wade Hampton Frost (1880–1938) and converted into a single-family home. Dr. Frost was the first professor of epidemiology at Johns Hopkins University in the first Department of Epidemiology in the United States. The home still stands today. (WH.)

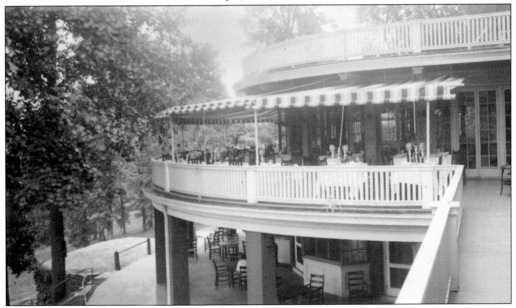

BALTIMORE COUNTRY CLUB VERANDA, 4712 CLUB ROAD (ROLAND PARK). The country club was founded in 1898 with 600 members and featured an 18-hole golf course on 150 acres. By the 1920s, a decision was made to open a second location north of the city. In 1930, the original clubhouse burned. The current clubhouse was built in its place in 1932 and stands on the remaining 28 acres. (MWW.)

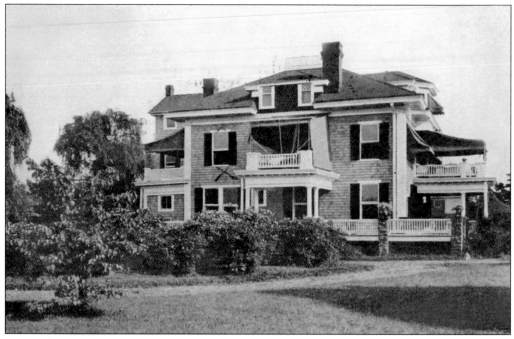

EMMA A. WIEDERHOLD, RN, CONVALESCING HOME, 5713 ROLAND AVENUE (ROLAND PARK). The beautiful home seen above, built in 1899, functioned in the 1920s and 1930s as a sanitarium. The sender of this card marked his room and mailed it to his daughter, Catherine Nissly, in Brookline, Massachusetts. He writes on the reverse, "This is a fine place. . . . We are so glad you are getting along nicely and are preparing for exams. Lovingly, Daddy." Below, the ornate woodwork of this home and the many pots of daisies was sure to welcome guests. Note the phone booth in the rear of the front hall. Today the home is divided into apartments. (WH.)

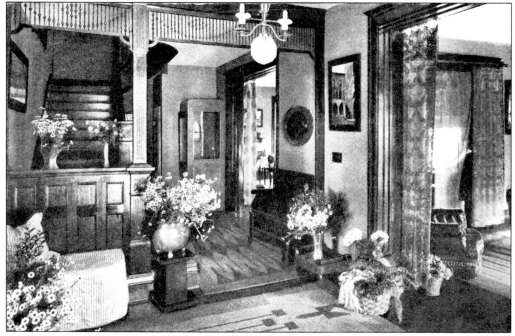

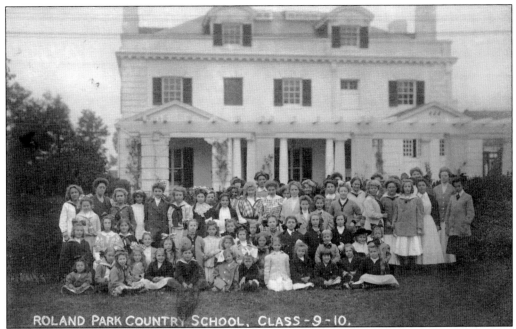

ROLAND PARK COUNTRY SCHOOL, CLASS OF 1909–1910, 4608 ROLAND AVENUE (ROLAND PARK). The school began in 1894 at the Keswick Road home of Katherine and Adelaide Howard with money borrowed from the Roland Park Company. By 1905, the school had moved to the Roland Avenue location depicted in this image. Although a girls' school today, it admitted boys up to fourth grade. The school moved to University Parkway in 1916 and to its current location at 5204 Roland Avenue in 1978 (www.rpcs.org). (WH.)

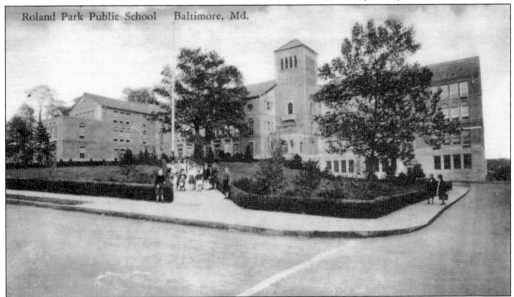

ROLAND PARK PUBLIC SCHOOL, 5207 ROLAND AVENUE (ROLAND PARK). The school was built in 1924. Originally known as Todd's Academy, the school was located at Roland Avenue and St. John's Road. After World War II, a wing was added to accommodate the expanding student body (www.rolandparkpublic.org). (WH.)

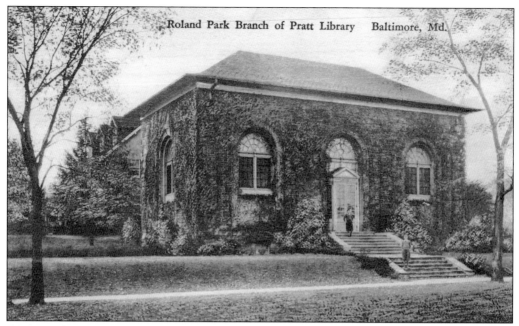

ROLAND PARK BRANCH OF THE ENOCH PRATT FREE LIBRARY, 5108 ROLAND AVENUE (ROLAND PARK). The library, built in 1921, still stands on Roland Avenue. In 2008, an extensive renovation and expansion were completed. The library was doubled in size. The high vaulted ceiling and arched windows were uncovered after 40 years of being hidden behind a drop ceiling. (WH.)

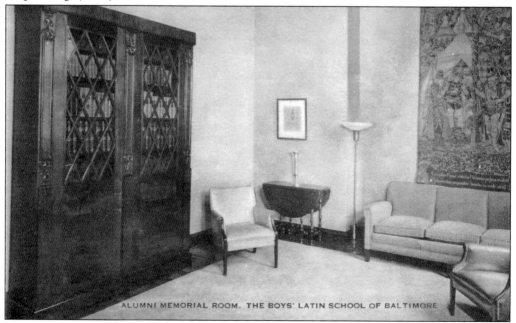

BOYS' LATIN SCHOOL OF MARYLAND, ALUMNI ROOM, 822 WEST LAKE AVENUE (ROLAND PARK). Founded in 1844, Boys' Latin School is the oldest, nonsectarian day school for boys in the Baltimore area. The school was located on Brevard Street until 1959 when it moved to its present location (www.boyslatinmd.com). (WH.)

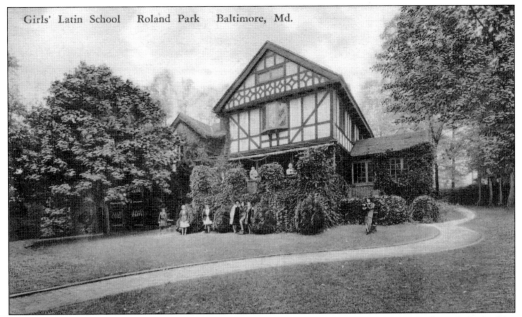

Girls' Latin School Roland Park Baltimore, Md.

GIRLS' LATIN SCHOOL, 10 CLUB ROAD (ROLAND PARK). The school was founded in 1890 as a preparatory to Goucher College. In 1909, it became independent from Goucher College and was located in the Winans mansion on St. Paul Street. In 1927, the school moved into this home. Built in 1903, it was the former home of Alexander Payson Knapp (1870–1927), vice president of United States Fidelity and Guaranty (USF&G). The school closed in 1951. The home still stands today and has been converted into apartments. (WH.)

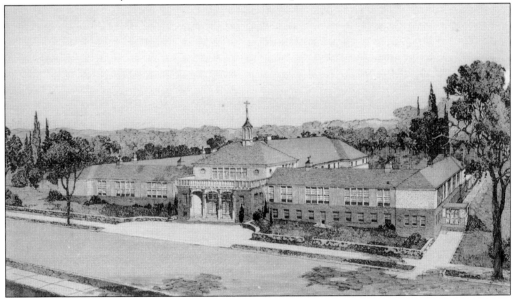

CALVERT SCHOOL, 105 TUSCANY ROAD (TUSCANY-CANTERBURY). The school was founded in 1897 and originally located above a pharmacy in Baltimore City. Its first headmaster, Virgil M. Hillyer, named the school after the family of Lord Baltimore. The current school, depicted here, was built in 1924 and designed by renowned Baltimore architect Lawrence Hall Fowler (www.calvertschool.org). (WH.)

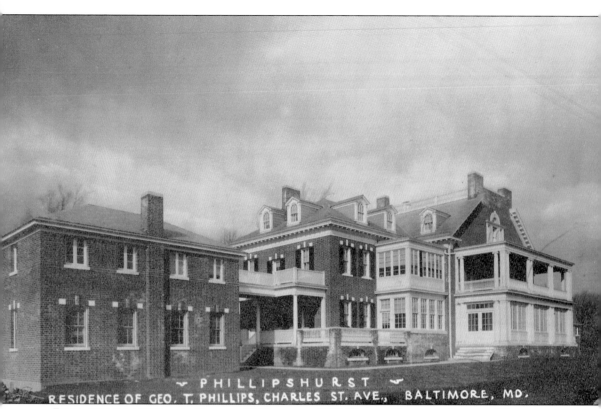

PHILLIPHURST, HOME OF GEORGE T. PHILLIPS, 3704 NORTH CHARLES STREET (TUSCANY-CANTERBURY). This palatial brick Colonial home was built in 1913 for George T. Phillips (1862–1940), president of D. E. Foote and Company, a Baltimore cannery of oysters and other food items. The reverse of this postcard carried a descriptive message regarding the house: "This shows the garage connected with the house by a bridge. The boy has an automobile of his own. There is a bath room for every two bedrooms—and there are 15 bedrooms—and so many balconies." The home burned in the 1920s, and the Phillips family moved to nearby 1 Wendover Road. The St. James Condominiums stands in its place today. (WH.)

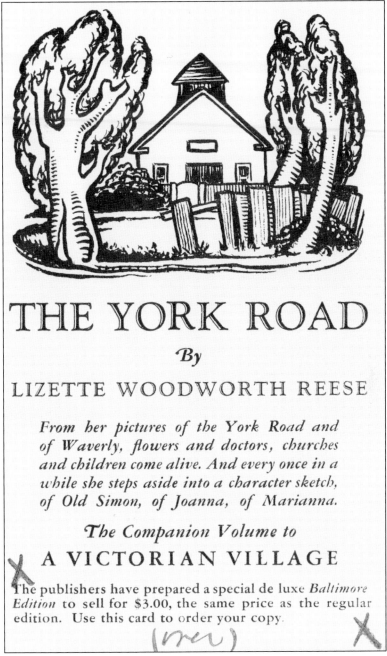

THE YORK ROAD

By

LIZETTE WOODWORTH REESE

*From her pictures of the York Road and
of Waverly, flowers and doctors, churches
and children come alive. And every once in a
while she steps aside into a character sketch,
of Old Simon, of Joanna, of Marianna.*

The Companion Volume to

A VICTORIAN VILLAGE

The publishers have prepared a special de luxe *Baltimore
Edition* to sell for $3.00, the same price as the regular
edition. Use this card to order your copy.

THE YORK ROAD BY LIZETTE WOODWORTH REESE, 1931 (WAVERLY). Lizette Woodworth
Reese (1856–1935) was born in Waverly. She was a schoolteacher and poet who taught in
Baltimore City for 45 years, 21 of them at Western High School. She published nine books of
poetry, which has been compared to Emily Dickinson's. This postcard advertises her memoirs,
entitled *The York Road*, published in 1931. This book is a companion volume to her previously
published memoirs, *A Victorian Village: Reminiscences of Other Days*, published in 1929. At
one time, she lived at 2926 Harford Road, and she is buried in St. John's Episcopal Church's
cemetery in Waverly. (WH.)

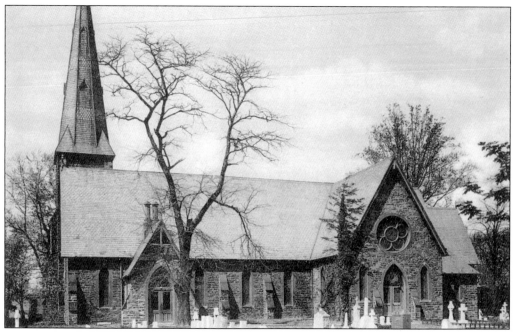

ST. JOHN'S EPISCOPAL CHURCH, 3009 GREENMOUNT AVENUE (WAVERLY). St. John's congregation has been worshipping at this site since 1843. The first church was built in 1847 but was lost to fire only 11 years later. The church depicted here was erected in 1859 to replace the first church. The Parish House was added in 1866, followed by the rectory in 1968, both in an English Gothic style (www.stjohnsinthevillage.org). (WH.)

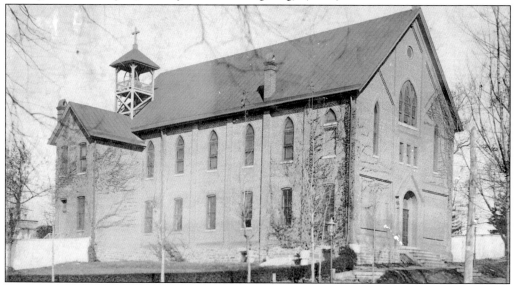

ST. BERNARD'S ROMAN CATHOLIC CHURCH, 934 GORSUCH AVENUE (WAVERLY). Built in 1927 on the corner of Gorsuch Avenue and Independence Street, the church served the Catholic community in Waverly for 62 years. In 1989, it became a Korean National parish named Holy Korean Martyr Catholic Church. The Korean congregation relocated to Woodlawn in 1997. The Archdiocese of Baltimore sold the church to its current occupant, the United Church of Jesus Christ, Apostolic. (WH.)

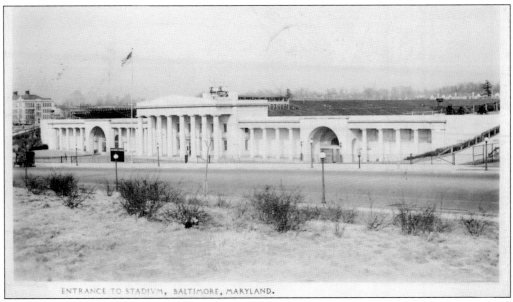

ENTRANCE TO STADIVM, BALTIMORE, MARYLAND.

BALTIMORE STADIUM, THIRTY-THIRD STREET (WAVERLY). Built in 1922, Memorial Stadium started its life as Baltimore Stadium, also known as Municipal Stadium. It was initially used as a football stadium. Baseball came to Thirty-third Street in 1944, when the Baltimore Orioles Park was destroyed by fire. The Greco-Roman facade was lost when the stadium was renovated in 1950 and renamed Memorial Stadium. The Orioles moved to Camden Yards in 1991. Memorial Stadium was demolished in 2001, and senior housing now occupies the site. (WH.)

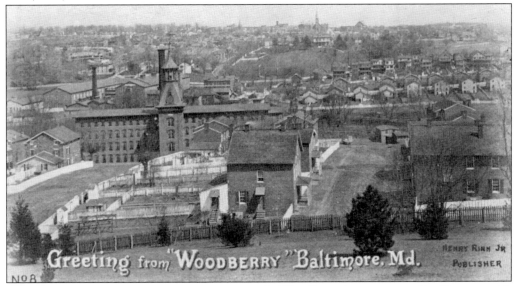

Greeting from "WOODBERRY" Baltimore, Md. HENRY RINN JR PUBLISHER

GREETINGS FROM WOODBERRY (WOODBERRY). Woodberry began as a small mill town, with its first flour mill created in 1802 to process grain grown in Frederick County for export. By 1820, the Baltimore area was a world center for flour milling. Cotton duck grew in popularity soon after, and by the 1830s, most of the flour mills had been converted to cotton mills. Many of the mill workers' stone houses still stand and are listed on the National Register of Historic Places. (WH.)

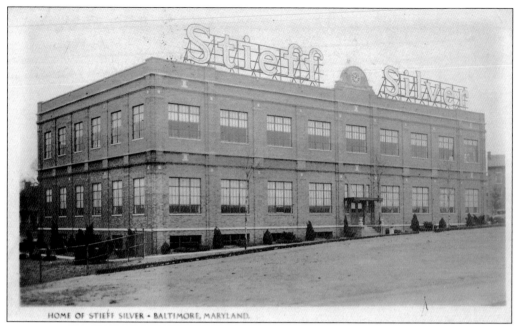

HOME OF STIEFF SILVER · BALTIMORE, MARYLAND.

THE STIEFF SILVER COMPANY (WYMAN PARK). The Stieff Silver Company was founded by Charles Stieff in 1914 in a small shop on Redwood Street. Stieff, grandson of the famed piano maker of the same name, began working as a silversmith in 1892. The building shown above was built in 1925. In 1979, the company acquired the silversmith company of Samuel Kirk and Son and changed its name to Kirk Stieff Company. Operations ceased in 1999, but the name survives as a brand name for stainless-steel flatware from Lenox, Inc. The building was converted into office space and is on the National Register of Historic Places. Below is a postcard depicting some of the finest work of the Stieff Company. The card reads, "Presented by the citizens of Maryland to His Eminence James Cardinal Gibbons on the occasion of the 25th year of his Cardinalate and the 50th year of his priesthood. October 7th, 1911." (WH.)

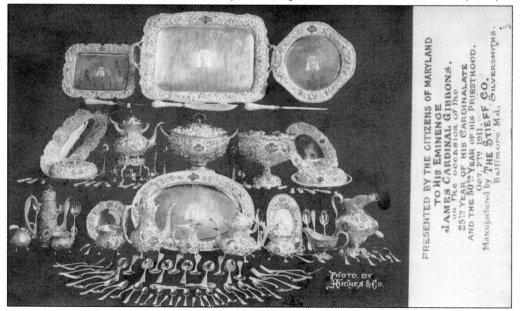

Two

THE NORTHEAST

CLIFTON PARK, COLDSPRING, HAMILTON, LAURAVILLE, MAYFIELD, MONTEBELLO, OVERLEA

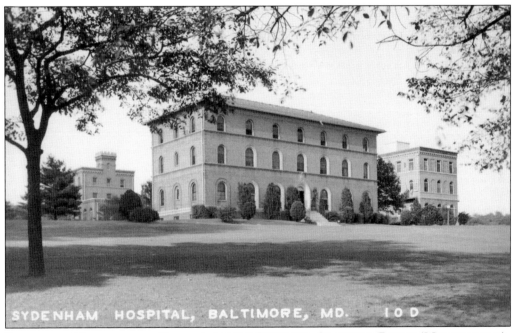

SYDENHAM HOSPITAL FOR COMMUNICABLE DISEASES, ARGONNE DRIVE (MONTEBELLO).
Built in 1924, Sydenham Hospital was designed by prominent Baltimore architect Edward Hughes Glidden Sr. A number of treatments were pioneered at Sydenham, allowing for the development of breakthrough procedures in the field of communicable diseases. After the hospital closed in 1949, the site was assumed by the Montebello State Chronic Disease Hospital. The property has been vacant since 1984 and awaits restoration. It was placed on the National Register of Historic Places in 1998. (WH.)

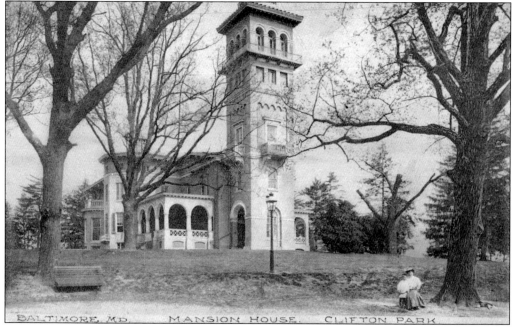

CLIFTON MANSION AND RESERVOIR (CLIFTON PARK). Clifton Mansion is best known for its last owner, Johns Hopkins (1795–1873). Hopkins, however, was not the first owner. The original section of the house was built in 1803 by Baltimore merchant Henry Thompson. Hopkins purchased the mansion and its 166 surrounding acres in 1840 at public auction. He enlarged the mansion, added a lake, and renovated the facade to replicate an Italian villa, a popular style of the time. Hopkins incorporated the Johns Hopkins University and Hospital in 1867. He wanted the university to be built on the estate, but it was decided after his death to locate the campus closer to downtown Baltimore. Below is the octagonal reservoir gatehouse built in 1887. Water from Lake Montebello once ran through the valves (grates) under the gatehouse on its way south to supply homes and businesses in the city. (Above MWW; below WH.)

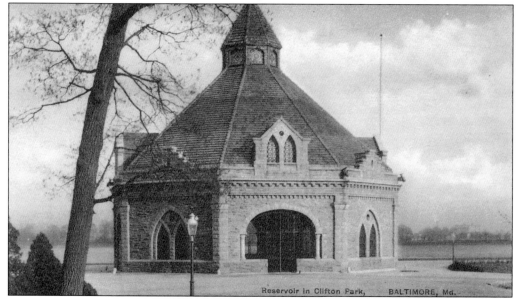

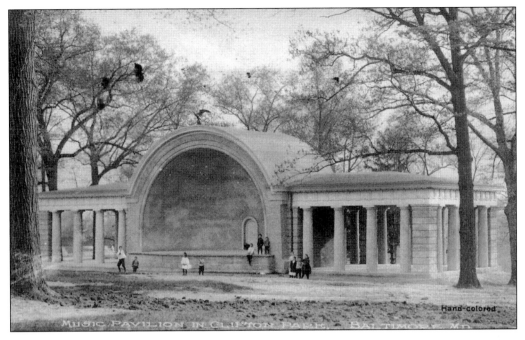

Hand-colored

MUSIC PAVILION IN CLIFTON PARK, BALTIMORE, MD.

CLIFTON PARK MUSIC PAVILION AND SWIMMING POOL (CLIFTON PARK). After Hopkins's death, the house was unoccupied until his trustees sold the property to Baltimore City in 1895 for $722,000. A city park was established, and the city's first public 18-hole golf course was added in 1915, which is still in operation today. Above is the music pavilion in its heyday. Today only the bowl remains. Below is an image of children enjoying the pool added to the park in 1950. (WH.)

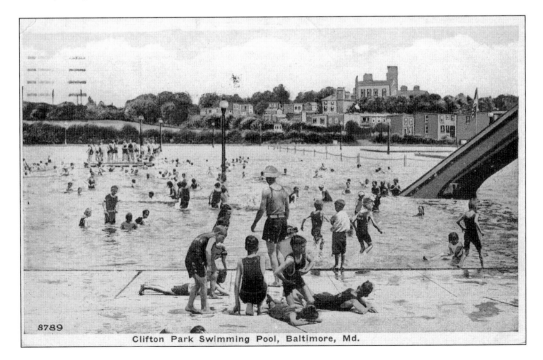

8789

Clifton Park Swimming Pool, Baltimore, Md.

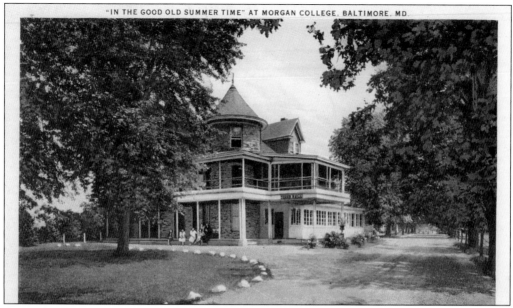

"IN THE GOOD OLD SUMMER TIME" AT MORGAN COLLEGE, BALTIMORE, MD.

MORGAN STATE UNIVERSITY, YOUNG HALL (COLDSPRING). Founded in 1867 as the Centenary Biblical Institute by the Baltimore Conference of the Methodist Episcopal Church, the institution's original mission was to train young men in ministry. It subsequently broadened its mission to educate both men and women as teachers. The school was renamed Morgan College in 1890 in honor of the Reverend Lyttleton Morgan, the first chairman of its board of trustees, who donated land to the college. (WH.)

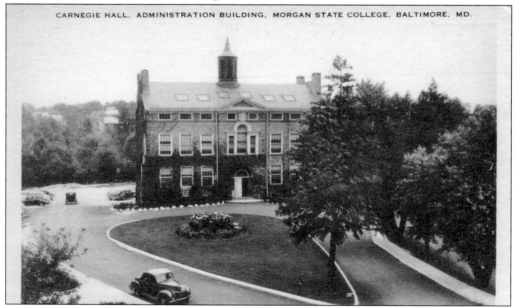

CARNEGIE HALL, ADMINISTRATION BUILDING, MORGAN STATE COLLEGE, BALTIMORE, MD.

MORGAN STATE UNIVERSITY, CARNEGIE HALL (COLDSPRING). In 1915, the late Andrew Carnegie gave the school a conditional grant of $50,000 for the central academic building. The terms of the grant included the purchase of a new site for the college, payment of all outstanding obligations, and the construction of a building to be named after him. The college met the conditions and moved to its present site in northeast Baltimore in 1917. (WH.)

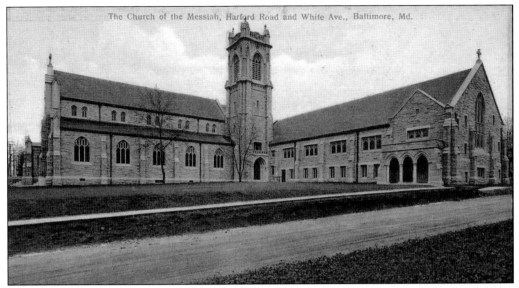

The Church of the Messiah, Harford Road and White Ave., Baltimore, Md.

THE CHURCH OF THE MESSIAH, 5801 HARFORD ROAD (HAMILTON). The church was founded in 1872 in the old Christ Church building at Fayette and Gay Streets. In 1904, Messiah was the only church building to be destroyed in the Great Baltimore Fire. The church was rebuilt the following year. The rebuilt downtown district became increasingly commercialized, causing the parish to decide in 1920 to relocate to Hamilton. The Tiffany Christ window over the altar, the pews, the eagle lectern, and many other furnishings were moved from the rebuilt downtown structure to Hamilton (www.messiahbaltimore.org). (WH.)

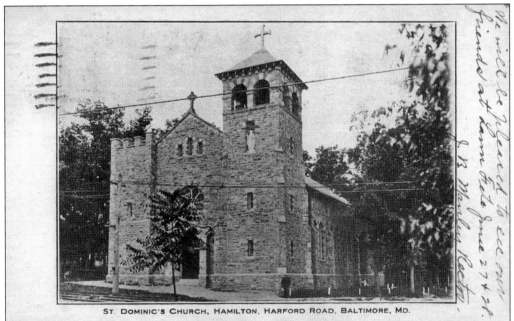

ST. DOMINIC'S CHURCH, HAMILTON. HARFORD ROAD, BALTIMORE, MD.

ST. DOMINIC ROMAN CATHOLIC CHURCH, 5310 HARFORD ROAD (HAMILTON). St. Dominic Roman Catholic Church was built in 1907. A priest can be seen standing at the base of the bell tower. The note reads, "We will be pleased to see our friends at Lann Fete June 27 and 28. J. B. Marley, Rector," postmarked June 25, 1911 (www.stdominicarchbalt.org). (WH.)

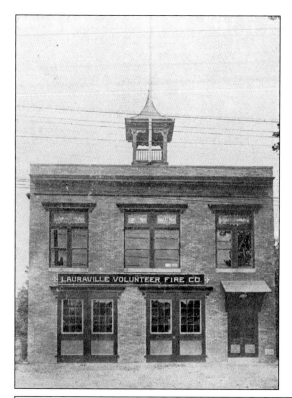

LAURAVILLE VOLUNTEER FIRE COMPANY (LAURAVILLE). With roots in the early 1800s, Lauraville was named after Laura Keene, whose father helped establish the post office for the then mill and farming village. The firehouse seen here was built in 1912, replacing the previous one. The current Lauraville firehouse was constructed on the site. (WH.)

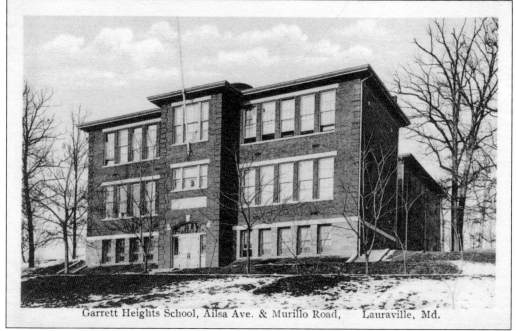

Garrett Heights School, Ailsa Ave. & Murillo Road, Lauraville, Md.

GARRETT HEIGHTS SCHOOL, 2800 AILSA AVENUE (LAURAVILLE). In 1895, land was acquired from the Garrett family for a schoolhouse, which was built in the late 1890s at Morello and Ailsa Avenues. The 1932 addition to the school is the only portion still standing. The older wing was destroyed by fire in 1969. (WH.)

St. Matthew's Church, Mayfield, Norman and Lake Avenues, Baltimore, Md.

ST. MATTHEW'S CHURCH, 3400 NORMAN AVENUE (MAYFIELD). The congregation, organized in 1852, worshipped for 75 years at Fayette Street and Central Avenue. In 1874, three cannons, captured in the Franco-Prussian War, were given to the church and cast into church bells. Eight bells to complete a chime of 11 were added. Erected in 1929, the architecturally beautiful church remains the anchor of the Mayfield community. (WH.)

COTTAGE GROUP—MARYLAND SCHOOL FOR THE BLIND, OVERLEA, MD.

MARYLAND SCHOOL FOR THE BLIND, 3501 TAYLOR AVENUE (OVERLEA). Originally founded as the Maryland Institution for the Instruction of the Blind, the school first opened its doors in downtown Baltimore in 1853. In 1868, the school moved the campus to much larger quarters on North Avenue and changed the name to the Maryland School for the Blind. In 1908, the school moved to its present location in Overlea. In 1909, cottages were built on the campus, beginning the first cottage system for instruction of the blind. (WH.)

Three

THE EAST

BIDDLE STREET, EAST BALTIMORE, MIDWAY, JOHNSTON SQUARE, OLDTOWN

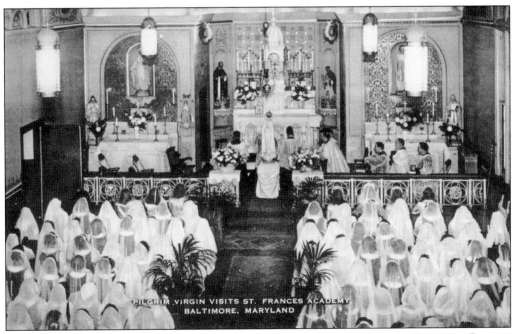

ST. FRANCES ACADEMY, PILGRIM VIRGIN VISIT, 501 EAST CHASE STREET (BIDDLE STREET). The academy was founded in 1828 by Mother Mary Lange, foundress of the Oblate Sisters of Providence. Mother Lange, born in Haiti, immigrated to Baltimore about 1813. Being a free black woman in an enslaved state, she saw the need to educate children of color and began the academy in her home. Today the academy is a high school. (MWW.)

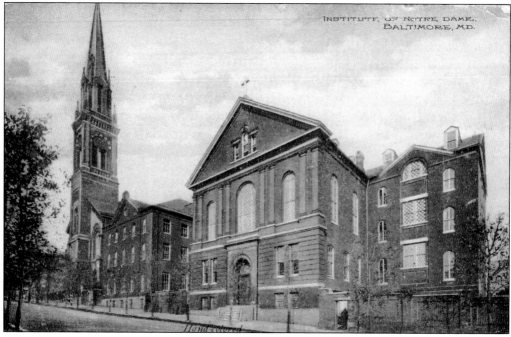

INSTITUTE OF NOTRE DAME HIGH SCHOOL, 901 NORTH AISQUITH STREET (OLDTOWN).
The Institute of Notre Dame, originally called the Collegiate Institute for Young Ladies, was established in 1847 by the School Sisters of Notre Dame. Both day and boarding students were accepted but has since become a day school only. The first school building was demolished, and St. James Church took its place. The oldest building, seen in the image above, was constructed in 1852. After the Civil War, the course study is known to have included etymology, elocution, sacred and profane history, German, French, Spanish, plain needlework, and vocal music. (WH.)

RECEPTION HALL, INSTITUTE OF NOTRE DAME, BALTIMORE, MD.

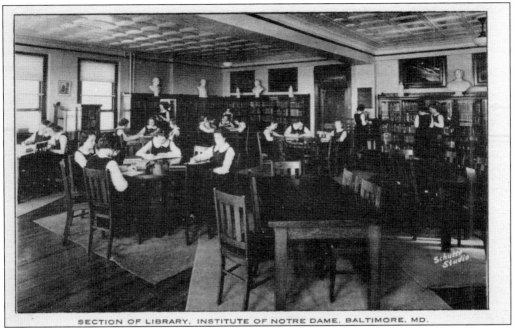

SECTION OF LIBRARY, INSTITUTE OF NOTRE DAME, BALTIMORE, MD.

INSTITUTE OF NOTRE DAME HIGH SCHOOL LIBRARY (OLDTOWN). The Institute of Notre Dame was among the first schools in Baltimore to provide young women with both a classic and business curriculum. As early as 1896, the school offered an academic-business course of study. (WH.)

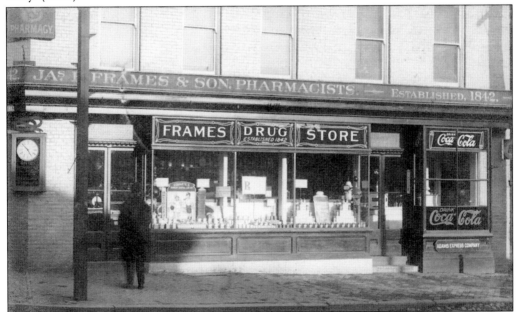

JAMES FRAMES AND SON PHARMACISTS, GAY AND AISQUITH STREETS (OLDTOWN). James Frames (died 1898) opened the pharmacy in 1842, which was in business for more than 60 years. His son, J. Fuller (died 1930), would follow in his footsteps and join his father in the family business. Fuller was president of the Maryland Pharmaceutical Association and secretary of the Calvert Drug Company for 20 years. (WH.)

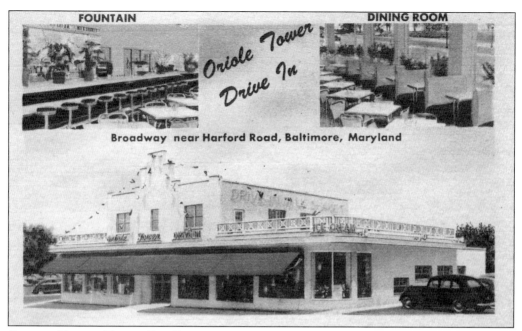

FOUNTAIN　　　**DINING ROOM**

Oriole Tower Drive In

Broadway near Harford Road, Baltimore, Maryland

ORIOLE TOWER DRIVE-IN, BROADWAY (EAST BALTIMORE MIDWAY). James P. Karukas started a bakery business (around 1930) known as the Oriole Tower Bakery, which later became a drive-in. He subsequently changed the drive-in to a full-service restaurant known as the James House. (WH.)

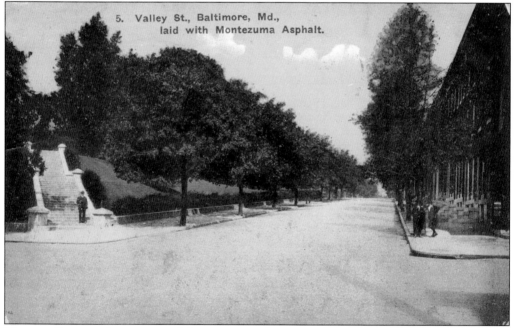

5. Valley St., Baltimore, Md.,
laid with Montezuma Asphalt.

VALLEY STREET LAID WITH MONTEZUMA ASPHALT (JOHNSTON SQUARE). The 1100 block of Valley Street can be seen in this image, with the entrance to Johnston Square on the left. Montezuma asphalt was made from crude oil and was used to pave streets in the early 1900s. (WH.)

50

Four

THE SOUTHEAST

CANTON, FELL'S POINT, HIGHLANDTOWN, HOPKINS BAYVIEW, LITTLE ITALY, MIDDLE EAST, PATTERSON PARK, WASHINGTON HILL

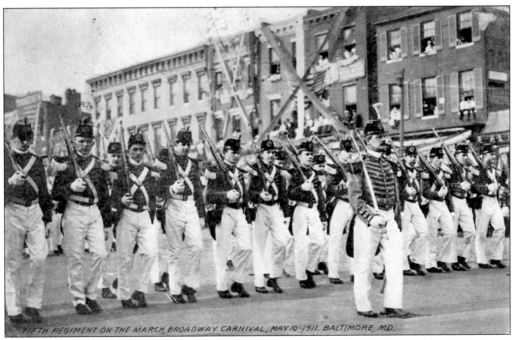

BROADWAY CARNIVAL, MAY 10, 1911 (FELL'S POINT). The 5th Regiment Army is depicted here marching in a parade during the Broadway Carnival. Broadway got its name from being one of the widest streets in Baltimore. (WH.)

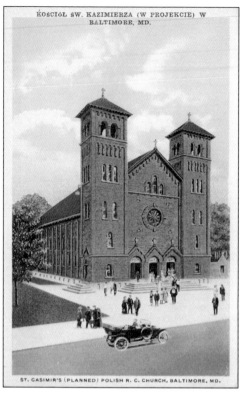

ST. CASIMIR'S PLANNED CHURCH, 2736 O'DONNELL STREET, C. 1923 (CANTON). Erected in 1926, the St. Casimir's depicted in this image varies much from the church standing today. The twin bell towers were heightened to 110 feet, with niches housing 9-foot-high statues of St. Francis of Assisi and St. Anthony of Padua. The exterior is of Indiana limestone. Instead of three triangular doorways, grand columns and a veranda were constructed. The architects were the firm of Palmer, Willis, and Lamdin (www.stcasimir.org). (WH.)

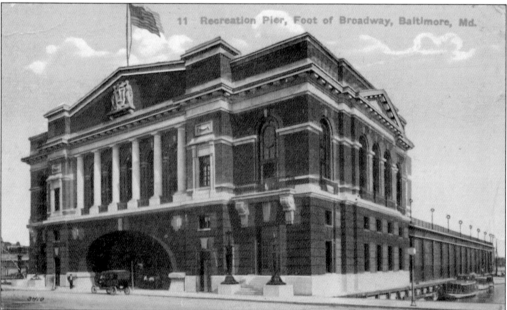

RECREATION PIER, THAMES STREET (FELL'S POINT). Built in 1914, the Recreation Pier once housed the harbormaster's office. Families used to gather on the pier for a swim or an afternoon of sunbathing. More recently, it served as a stand-in for a police station in the NBC drama *Homicide: Life on the Street*. In 2005, the building was included in the Heritage Preservation Tax Credit Program and is awaiting development. (WH.)

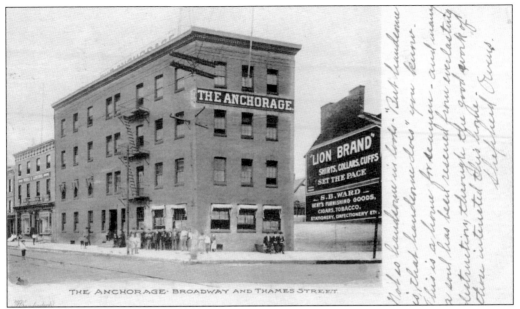

THE ANCHORAGE BROADWAY AND THAMES STREET

THE ANCHORAGE, SEAMAN'S YMCA, 888 SOUTH BROADWAY (FELL'S POINT). The Anchorage was built by the Port Mission Women's Auxiliary as a boardinghouse for merchant seamen and was later the Seamen's YMCA from 1929 until 1955. The rules of the house were that sailors had to be good Christians, had to bathe, and were subject to delousing if necessary. After serving for some 30 years as a vinegar bottling plant, the Anchorage became the Admiral Fell Inn. The inn, named for the founding father of Fell's Point, Adm. William Fell, is on the National Register of Historic Places. Note the addition added between the times the two photographs were taken. The sender of the above postcard, Shepherd Owens, writes, "Not so handsome in looks, 'but handsome is that handsome does' you know. This is a home for seamen—and many a soul has been rescued from everlasting destruction through the good work of those interested in this home" (www.harbormagic.com). (WH.)

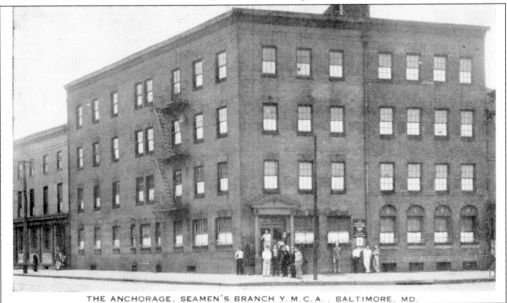

THE ANCHORAGE, SEAMEN'S BRANCH Y.M.C.A., BALTIMORE, MD.

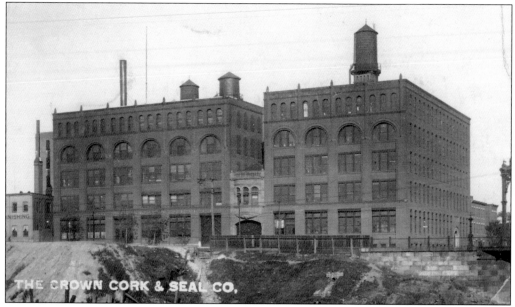

THE CROWN CORK AND SEAL COMPANY (HIGHLANDTOWN). This present-day international company was originally headquartered in Baltimore. Founder William Painter patented his "crown cork," more commonly known as the bottle cap, in 1892. The factory building depicted here was completed in 1917. (WH.)

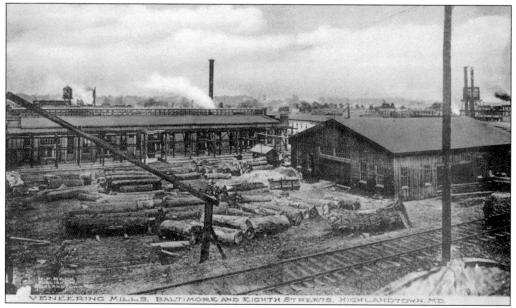

WILLIAMSON VENEERING MILLS LOG YARD, BALTIMORE AND NORTH HAVEN STREETS (HIGHLANDTOWN). Williamson Veneer Company was founded in the 1870s in Indianapolis, Indiana, by Marshall D. Williamson, the pioneer in the veneer business. In 1900, his son Dwight moved the company to Baltimore. The mill was destroyed by fire in 1904 but immediately rebuilt. The City Directory shows the business at this location until 1937. Note the postcard lists the location as Eighth Street, which was later changed to Haven Street. The site is an industrial lot today. (WH.)

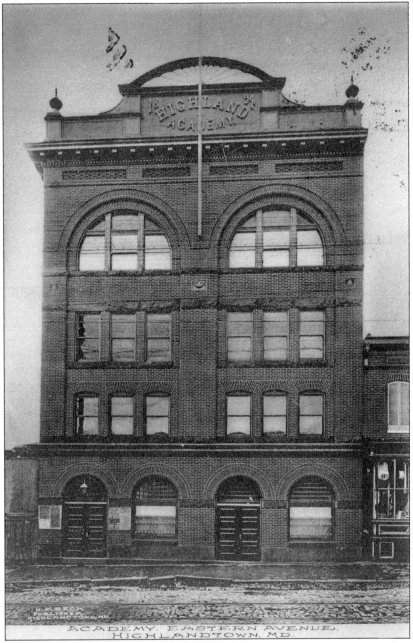

HIGHLAND ACADEMY, 3509–3511 EASTERN AVENUE (HIGHLANDTOWN). The Highland Academy building, also known as Conkling Hall, was built by Philip Wagner in 1894. The facility was a popular place for dances and a variety of fraternal organizations. There was a banquet hall on the first floor and two large lodge rooms on the third floor. The second floor was used as a ballroom. The Highland Theater also used the second-floor space from 1895 to 1919, when it moved to a home of its own at 3829 Eastern Avenue. The academy was an early home for the German social club and singing society known as the Eichenkranz Society. By 1913, the building was sold to William J. Wieland and converted into a furniture store. Today it houses medical offices. (WH.)

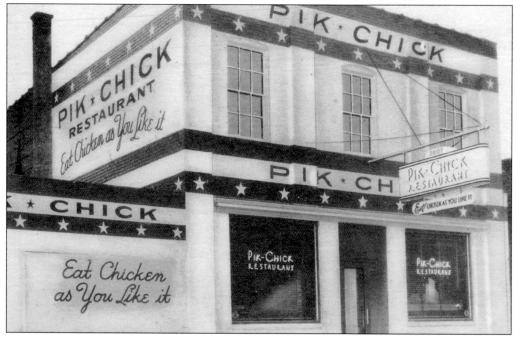

PIK-CHICK RESTAURANT, 3607 FLEET STREET (HIGHLANDTOWN). The *c.* 1920 building was home to the Pik-Chick Restaurant. Today it is home to the Quest Bar. The reverse of this postcard reads, "We crow about quality—is the only place in Baltimore to get the famous Pik-Chick fried chicken. Why cook at home, follow those who know, phone Wolfe 5666 for reservations." (WH.)

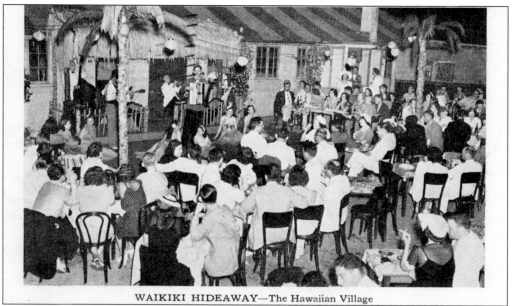

WAIKIKI HIDEAWAY—The Hawaiian Village

WAIKIKI HIDEAWAY—THE HAWAIIAN VILLAGE, 2500 NORTH BOWLEYS LANE (HIGHLANDTOWN). The Waikiki Hideaway lounge brought a little bit of Hawaiian paradise to Baltimore. This outdoor lounge provided authentic Hawaiian music and dancing. The building has since been razed. (WH.)

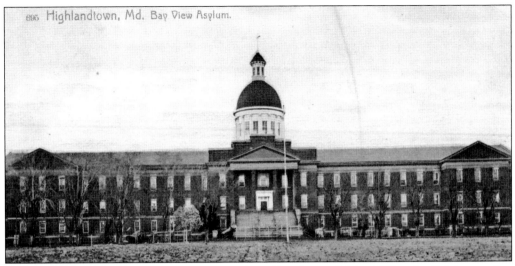

BAY VIEW ASYLUM (HOPKINS BAYVIEW). Bay View began life in 1773 as the Baltimore City and County Alms House on the west side of Baltimore. In 1866, the almshouse was moved to its present location and renamed Bay View Asylum. It housed the poor and insane and was known as a dreaded, sinister place. In 1925, it was renamed Baltimore City Hospitals. It encompassed three separate hospitals. In 1982, the hospitals became part of the Johns Hopkins Hospital. The structure is now part of the Mason F. Lord building (www.hopkinsbayview.org). (WH.)

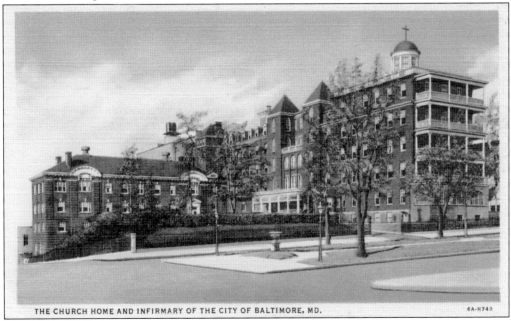

CHURCH HOME AND INFIRMARY, 100 NORTH BROADWAY (WASHINGTON HILL). Church Home was formerly the Washington Medical College, opened in 1836. Many of the doctors who served in the Union and Confederate armies during the Civil War were trained here. In 1857, the building was purchased for $20,500 by an Episcopalian group and reopened as Church Home and Infirmary, a joint operation run under the control of St. Andrew's Infirmary and the Church Home Society. Edgar Allen Poe died at the hospital in 1849. The hospital closed in 2000 and now serves as offices for Johns Hopkins University. (WH.)

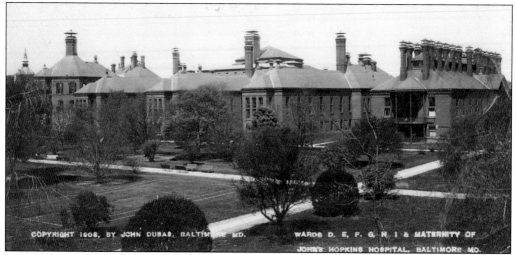

JOHNS HOPKINS HOSPITAL, 1908 (MIDDLE EAST). The hospital's construction began in 1877 and took 12 years to complete. Seventeen hospital buildings were constructed pavilion-style, arranged around an open courtyard. The buildings were designed to prevent spread of disease and, as seen here, had many chimneys to provide maximum air circulation. Only three of the original buildings still stand today. In 1976, the hospital was placed on the National Register of Historic Places (www.hopkinsmedicine.org). (WH.)

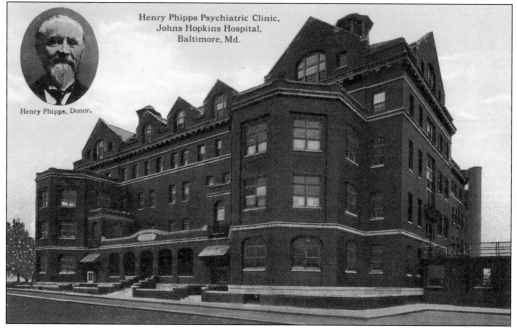

HENRY PHIPPS PSYCHIATRIC CLINIC, JOHNS HOPKINS HOSPITAL (MIDDLE EAST). The Edwardian-style clinic was designed by architect Grosvenor Atterbury and dedicated in 1913. It is named for Henry Phipps, a Pittsburgh steel magnate who paid for its construction. The building originally had marble floors, fireplaces, and a pipe organ. Zelda Fitzgerald was among the many patients treated in what was the first psychiatric clinic in the country associated with an academic medical center. The clinic underwent restoration in 1983 and remains a psychiatric facility today. (WH.)

THOMAS WIDLEY MONUMENT, BROADWAY (WASHINGTON HILL). Thomas Widley (1782–1861), a native of London, rose quickly through the chairs of the Odd Fellows Lodge in England. He later moved to Baltimore and established the first Odd Fellows Lodge in the United States in 1819. The monument to him was erected on Broadway in 1865. (WH.)

BROADWAY MARKET, BROADWAY (FELL'S POINT). This market was established in 1784. In 1797, the market was moved to the center of Broadway. Several structures have housed the market. The present market was built in 1864 and topped with a second story used for social and civic affairs. A fire in the 1960s destroyed the second floor, and it was removed. Many of the stalls today have been operated by the same family for several generations. (WH.)

59

New Eastern High School, Baltimore, Md.

EASTERN FEMALE HIGH SCHOOL, ASQUITH AND ORLEANS STREETS. Baltimore was one of the first public school districts to recognize that females needed the same higher education as males. Founded in 1844, it was decided that two schools were to be built, Eastern and Western on their respective sides of town, because "females were more delicate than males and cannot attend school at remote distance." Since the school was to be a free school, it was feared that it would be considered a charity school, so a $1 quarterly tuition was charged. The first school was located at Front and Fayette Streets. By the late 1860s, the building was in great disrepair and the student body had outgrown it. The Asquith Street building was constructed in 1870 with 350 students in attendance. The school moved again in 1907 to North Avenue (seen above) and in 1933 to its present location. (Above MWW; below WH.)

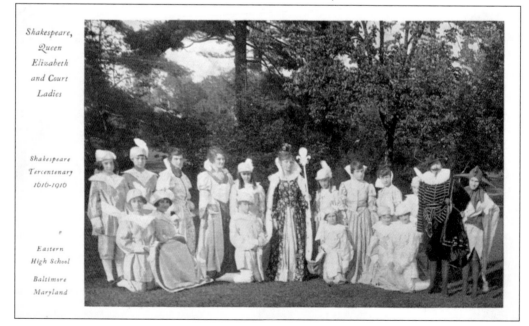

Shakespeare, Queen Elizabeth and Court Ladies

Shakespeare Tercentenary 1616-1916

Eastern High School

Baltimore Maryland

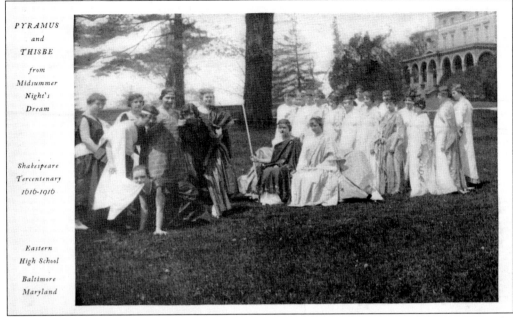

EASTERN FEMALE HIGH SCHOOL SHAKESPEAREAN TERCENTENARY, 1916. By 1916, the school had moved to its third home at North Avenue and Broadway. The school celebrated the 300th anniversary of William Shakespeare's death with a festival. To raise money for the event, postcards such as these, as well as bookplates, were sold. The festival took place on May 26, 1916, in Lake Clifton Park. Thousands of paper flowers were made for the productions. There was certainly a reversal of roles at this event. In Shakespeare's day, all the female parts were played by men and boys. Eastern students and alumnae played all of the roles. The festival was one of the biggest projects ever undertaken by Eastern. (WH.)

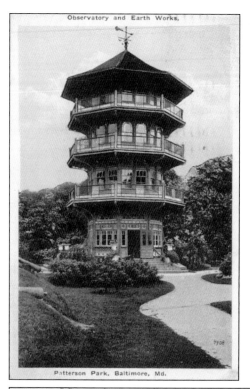

PATTERSON PARK PAGODA (PATTERSON PARK). Patterson Park was named for William Patterson (died 1835), who donated 6 acres of his 200-acre tract for a Public Walk in 1827. The pagoda was erected in 1892. It was designed by Charles Latrobe, superintendant of parks, as an observation tower. On Hampstead Hill, the ridge where the pagoda stands, Baltimoreans rallied on September 12, 1814, to protect the city from the threat of a British invasion. (WH.)

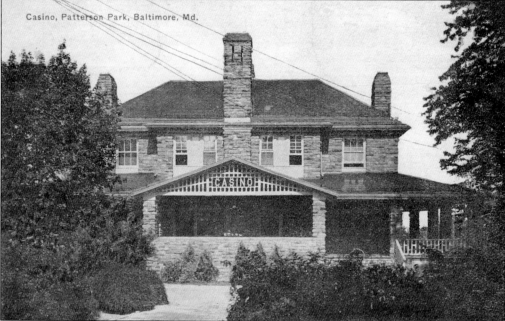

CASINO, PATTERSON PARK (PATTERSON PARK). Originally known as the Mansion House, the Casino was designed by Charles H. Latrobe and built by Cornelius Sheehan in 1893. First used as a refreshment stand, it has served a number of purposes over the years, including a park office with basement tool house, an upper-story suite of residential apartments, and public restrooms. It now houses an adult day care center and a facility for small meetings. (WH.)

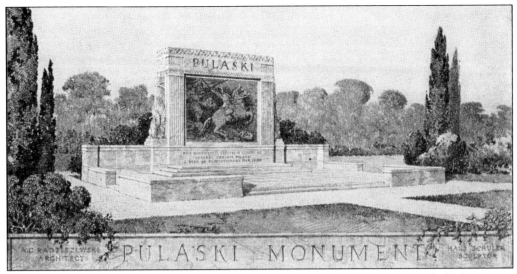

PATTERSON PARK PULASKI MONUMENT (PATTERSON PARK). Kasimierz Pulaski, known in America as Count Casimir Pulaski (1747–1779), was a Polish patriot and hero of the Polish anti-Russian insurrection. On a visit to Paris, Benjamin Franklin met the count and recommended him to Gen. George Washington. He fought in the American Revolution. In 1779, he defended Charleston and died from wounds he received in Savannah. The cornerstone was laid in 1928, and the monument was finished and dedicated in 1951. Hans K. Schuler (1874–1951) was the sculptor. (WH.)

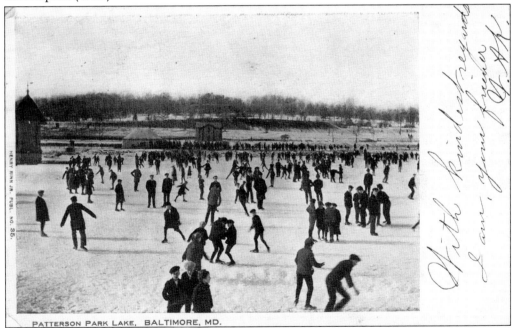

ICE SKATING IN PATTERSON PARK, C. 1905 (PATTERSON PARK). The Patterson Park Boat Lake was created in 1864 during grading operations to remove military emplacements and to fill ravines. Today the lake is a combination of open water and a wetland habitat for fish, waterfowl, and songbirds, and renovation is underway. Ice skating is still a favorite activity at the park in the Dominic 'Mimi' DiPietro Family Skating Center. (WH.)

ROMA RESTAURANT, 231 SOUTH HIGH STREET (LITTLE ITALY). According to the reverse of this postcard, the restaurant was "famous for fine Italian and American Cuisine. Seafoods. Mentioned by Holiday Magazine on Baltimore as one of the Oldest and Best-Favored eating places for Italian food in the city." The 90-year-old row house is now home to Amicci's Italian restaurant (www.amiccis.com). (WH.)

Five

THE SOUTH

CURTIS BAY, FEDERAL HILL, LOCUST POINT, MIDDLE BRANCH PARK, OTTERBEIN, SOUTH BALTIMORE, UNION SQUARE

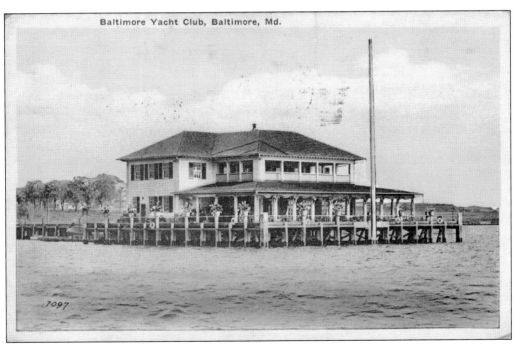

BALTIMORE YACHT CLUB (LOCUST POINT). The Baltimore Yacht Club was founded in 1891 in Curtis Bay. Because of encroaching industrialism, the club found a new home in 1912. The club leased a 500-foot pier from the MacLean Contracting Company of Locust Point, building the large clubhouse seen in the photograph at the end of the pier. In 1917, the club moved the clubhouse to Winans Cove near the Hanover Street Bridge. The clubhouse burned and dissolved in 1930. In 1939, the club was resurrected and is now located in Essex, Maryland (www.baltimoreyachtclub.org). (WH.)

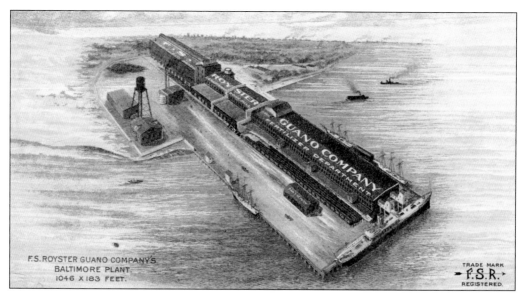

FRANK S. ROYSTER GUANO COMPANY (CURTIS BAY). Baltimore had several fertilizer plants along the Patapsco River at the beginning of the 20th century. Frank S. Royster (died 1967), a wealthy industrialist from Norfolk, Virginia, located his Baltimore plant at the end of Chesapeake Avenue, near Vera Street, on the Patapsco. The plant would later be known as the National Fertilizer Association. (WH.)

THE WALNUT GROVE, 3612 SOUTH HANOVER STREET (CURTIS BAY). The reverse of this card reads, "Maryland's newest, largest, most beautiful, fully air-conditioned night club, presents America's top name bands and variety stars of stage, screen and radio nightly. Seating 1,200. Parking for 500 cars. Superb drinks. Curtis 0367." The large parking lot and former bar is now home to a used car dealership named Associated Sales of Baltimore. (WH.)

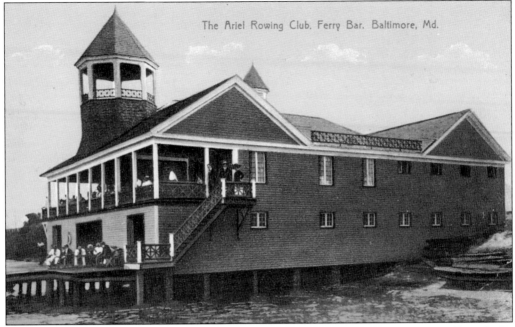

BALTIMORE ROWING CLUB, 3301 WATERVIEW AVENUE (MIDDLE BRANCH PARK). In 1864, the Baltimore Rowing Club was founded, later changing its name to the Ariel Rowing Club. The clubhouse was located at the Ferry Bar Landing near the Hanover Street Bridge. The Ariel was soon followed by the Undine and Zephyr. As a group, the local clubs called themselves the Patapsco Navy. The club disbanded and was later resurrected in 1979 at the Middle Branch Park location (www.baltimorerowing.org). (WH.)

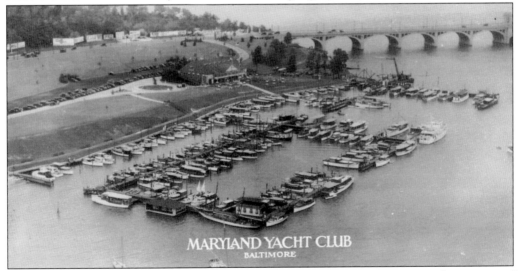

MARYLAND YACHT CLUB (MIDDLE BRANCH PARK). Organized in 1908 for owners of motorized boats, the yacht club was first named the Maryland Motor Board Club. It would later change its name to better reflect the sailboat members. Originally located on the Ferry Bar Landing, the club moved in 1925 to Broening Park, seen in this photograph, current location of the Harbor Hospital Center. In 1945, the club would make its last move to its present location in Pasadena, Maryland (www.mdyc.org). (WH.)

Federal Hill Park,

BALTIMORE, MD.

FEDERAL HILL PARK (FEDERAL HILL). Federal Hill was originally called John Smith's Hill after Colonial settler Capt. John Smith (1580–1631), who first laid eyes on "a great red bank of clay flanking a natural harbor basin." In 1788, Baltimoreans were celebrating the ratification of Maryland becoming a state. During a parade organized by Commodore Joshua Barney, Revolutionary War naval hero, a 15-foot model of a fully rigged sailing ship named the *Federalist* was put on wheels and placed on the hill. After a day of merrymaking and libations, Barney and fellow sailors pushed the boat down the hill (forever after known as Federal Hill) and into the water and sailed her to Annapolis. In 1795, a marine observation tower was installed on the hill. A second tower was built in 1880, only to be felled by a storm in 1902. A replica of the first tower has since been built. In 1814, Federal Hill was ready to do battle with invading British soldiers. The hill never saw battle because the British were stopped at Fort McHenry and retreated. During the Civil War, Baltimore had as many Southern sympathizers as it did Northern. The Union army aimed the cannons on the hill at the city as a message that succession was not an option. Popular legend is that there are a series of tunnels under the hill that lead to Fort McHenry. Tunnels were dug, but only as far as Henry Street, and were used to mine red clay. In 1880, this became an official city park still enjoyed today (www.federalhillonline.com). (MWW.)

LIGHT STREET PRESBYTERIAN CHURCH, 908 LIGHT STREET (FEDERAL HILL).

Built in 1855 as the Sabbath Presbyterian Church (renamed in 1871), the Light Street Presbyterian Church grew out of the first Sabbath School for South Baltimore's children. The Sabbath School met in Armstrong's Hall, located on the northeast corner of Light and Montgomery Streets. The stained glass was added in 1891. In 1902, the Adam-Stein pipe organ was built. Of the 20 Adam-Stein organs of this type that were made, only six remain (www.lightstreetchurch.org). (WH.)

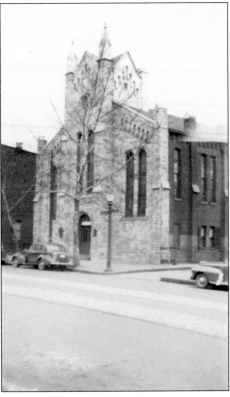

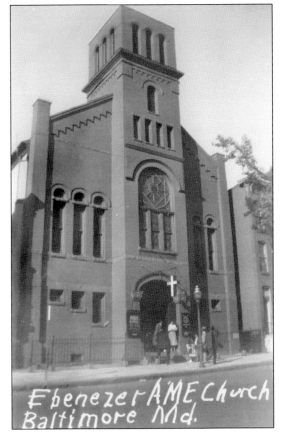

EBENEZER AFRICAN METHODIST EPISCOPAL CHURCH, 20 WEST MONTGOMERY STREET (FEDERAL HILL).

In 1839, the Zion African Wesleyan Church stood on this site. The growth of the African American community during the Civil War necessitated an expansion. The cornerstone for the current church was laid on the site of the former church in 1865 but was not completed until 1868. The church was placed on the National Register of Historic Places, saving it from being demolished when I-395 was built (www.ebenezer-amec-baltimore.org). (WH.)

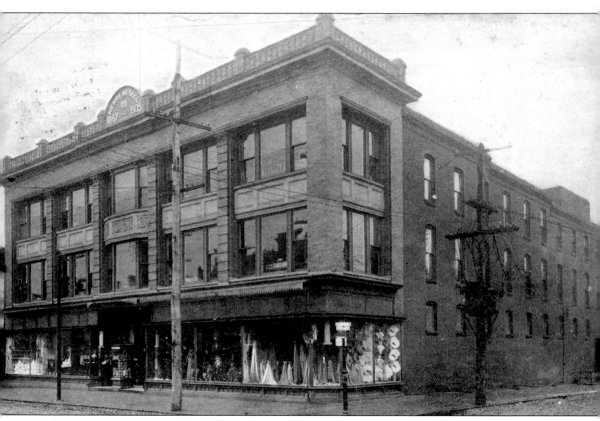

HENRY WESSEL COMPANY, 1000 SOUTH CHARLES STREET, C. 1908 (FEDERAL HILL).
Henry Wessel (born 1837) opened a dry goods store in this block in 1867. The business was such
a success that Wessel was able to buy and demolish six buildings on this block of Charles Street
and erect a single three-story department store by 1905. It operated until 1930 and remained
empty for the next 50 years, until it briefly became the home of the Reliable department store.
In the 1940s and 1950s, Food Fair occupied the first floor. In 1950, the Southway Bowling Alley
was opened on the second floor. Beginning in the 1970s, Steve's Supermarket would call the
first floor home for almost 20 years. Today the first floor is occupied by CVS drugstore. The
upper floors have been converted into nine loft condominiums (www.fhlofts.com). (WH.)

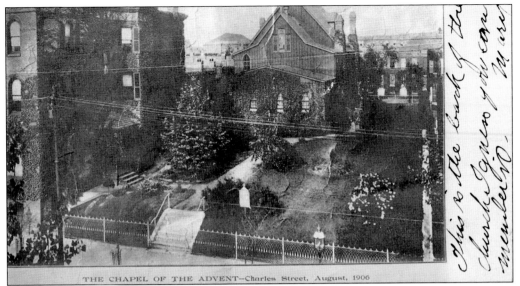

THE CHAPEL OF THE ADVENT—Charles Street, August, 1906

CHURCH OF THE ADVENT, 1301 SOUTH CHARLES STREET, C. 1909 (SOUTH BALTIMORE).
Grace Protestant Episcopal Church transferred its mission, Chapel of the Advent, from its longtime
location at 1300 Patapsco Street (directly behind the current church) to the new, larger church.
The former sanctuary was turned into the Sunday school building (at left). This photograph of
the rear of the church was taken from Patapsco Street (www.advent.ang-md.org). (WH.)

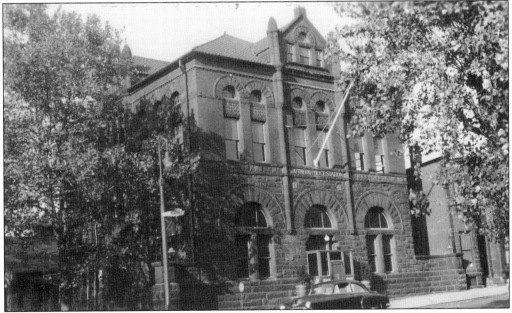

SOUTH BALTIMORE POLICE STATION, 24 EAST OSTEND STREET (SOUTH BALTIMORE).
This brick-and-sandstone fortress was opened by the Baltimore City Police Department as its
Southern District Stationhouse in 1897. The new station house replaced the original Southern
District Watch House at 130 West Montgomery Street, in use since the early 1840s. In 1986,
the station house moved to its current site in Cherry Hill. Today the old station house is home
to several nonprofit organizations. The building had a recurring role in the television series
Homicide. (WH.)

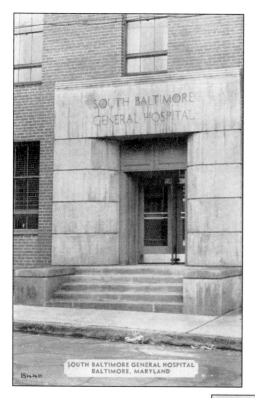

SOUTH BALTIMORE GENERAL HOSPITAL, 1211 LIGHT STREET, WALL STREET VIEW (SOUTH BALTIMORE). The hospital was established in 1900 by Dr. Harry Peterman (1870–1939) at 1017 Light Street and was originally named the South Baltimore Eye, Ear, Nose, and Throat Hospital. By 1903, ground was broken at 1211 Light Street for a 12-bed hospital. In 1914, a larger hospital was erected and renamed. In 1968, the hospital moved to the former Maryland Yacht Club location (see page 67). Today the hospital is known as Harbor Hospital Center. The Light Street building has been converted into condominiums (www.harborhospital.org). (MWW.)

RIVERSIDE BAPTIST CHURCH, 1602 JOHNSON STREET (SOUTH BALTIMORE). The church was founded as a Sunday school in 1882 by members of the Lee Street Baptist Church in a private home on the corner of Hanover and M'Cann Streets. Two years later, a more suitable permanent home was needed. Dedicated in 1884 and named for the nearby public park, the church's original brick facade was covered with Formstone in the 1950s (www. riverside-baptist.org). (WH.)

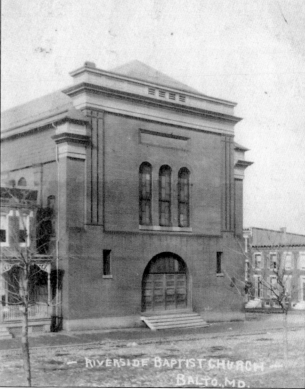

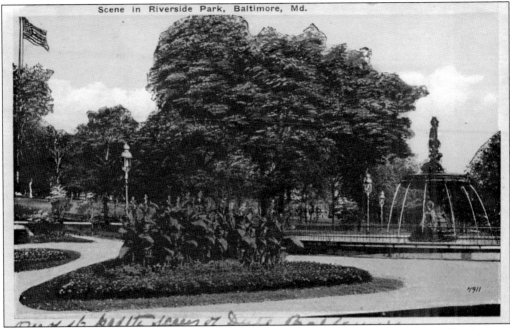

RIVERSIDE PARK, RANDALL AND JOHNSON STREETS (SOUTH BALTIMORE). During the War of 1812, Riverside Park was the location of a circular battery called Fort Lookout. The battery played a key role in the defense of the city. After the battle, the fort was renamed Fort Wood in honor of Capt. Eleazer Wood. In 1854, Baltimore City approved its use as a public park, renaming the property Battery Square. In 1873, the city purchased the land and renamed it Riverside Park. Originally the park had two pavilions, a greenhouse, and a large marble fountain in which goldfish swam. Today the swimming pool sits on the site of the fountain, and the 1812 cannons are climbed on daily by children. In 1976, the park was renamed the Leone-Riverside Park in memory of slain councilman Dominic Leone Sr. (www.riversideactiongroup.org). (MWW.)

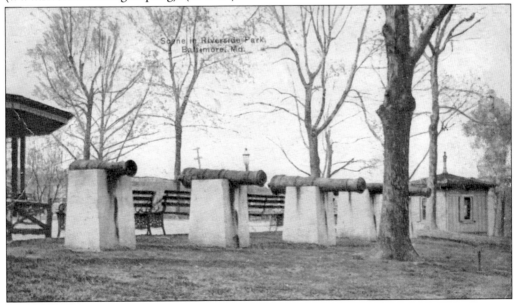

73

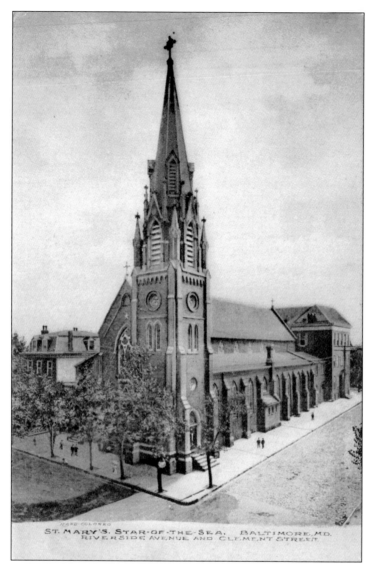

ST. MARY'S. STAR·OF·THE·SEA. BALTIMORE,MD.
RIVERSIDE AVENUE AND CLEMENT STREET

ST. MARY'S STAR OF THE SEA CHURCH, 1419 RIVERSIDE AVENUE (SOUTH BALTIMORE).
St. Mary's parish was established in 1868. Rev. Peter McCoy (1832–1895) was assigned to establish an independent parish. It took McCoy two years to raise the funds and build a brick Gothic church with a 150-foot steeple capped by a metal star. The star was illumined at night by a powerful gas jet, an innovative technological feat in its day, in tribute to the church's patroness St. Mary. Reverend McCoy's star was the subject of much controversy. The U.S. Coast Survey claimed it befuddled navigators of the Chesapeake Bay, who were mistaking it for a genuine heavenly body or one of the government's lighthouses listed on their charts. After considerable negotiation, it was arranged that St. Mary's be incorporated onto the navigational charts of the Chesapeake Bay as a fixed light, the first church steeple so designated. In 1886, the star was wired for electricity. In 1903, a tornado wrecked 250 South Baltimore row houses and brought down a portion of the steeple. It was repaired and shone until World War I, when it was extinguished. Why it was not relit after Armistice Day is unclear, but it remained dark until 1927. It was extinguished again for World War II and not immediately relit until 1949; it continues to shine today. (WH.)

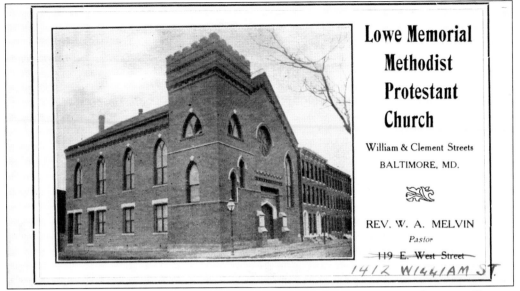

Lowe Memorial
Methodist
Protestant
Church

William & Clement Streets

BALTIMORE, MD.

REV. W. A. MELVIN
Pastor

~~119 E. West Street~~

1412 WILLIAM ST.

LOWE MEMORIAL METHODIST PROTESTANT CHURCH, 1412 WILLIAM STREET (SOUTH BALTIMORE). Rev. Thomas Lowe (1845–1917) first preached in South Baltimore under a tent at William and Gittings Streets in 1875. In 1876, he established the South Baltimore Free Methodist Society at 1232 William Street. By 1888, the church was located at this address and known as the William Street Independent Methodist Church. In 1928, it was renamed for its founder. It merged with another church in 1959 and became Good Shepard United Methodist. Good Shepard moved to Fort Avenue in 1966. Today the church has been converted into condominiums. (WH.)

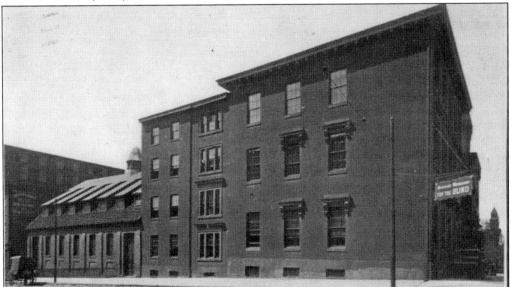

MARYLAND WORKSHOP FOR THE BLIND, JOHNSON STREET, C. 1910 (SOUTH BALTIMORE). The Maryland Workshop for the Blind was located on the corner of Johnson and Wells Streets. The organization taught sight-impaired individuals such skills as basket weaving, chair caning, and cloth making. The National Federation of the Blind's national headquarters occupies the space today. (WH.)

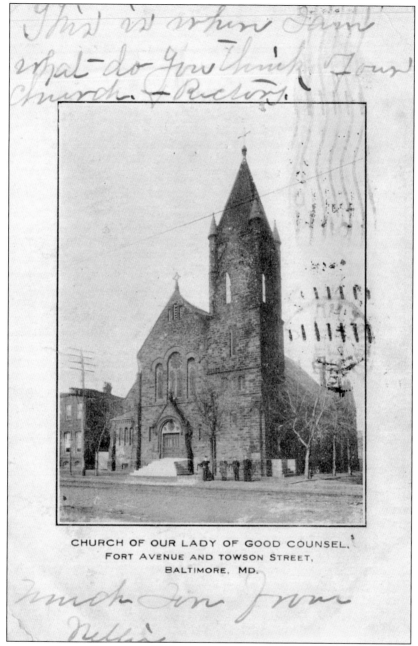

CHURCH OF OUR LADY OF GOOD COUNSEL,
FORT AVENUE AND TOWSON STREET,
BALTIMORE, MD.

OUR LADY OF GOOD COUNSEL, 1532 EAST FORT AVENUE (LOCUST POINT). In 1858, the parish began as a mission chapel named for Irish holy man St. Lawrence O'Toole. It was built on land given by John W. Ross. When St. Mary's Star of the Sea (see page 74) was established in 1869, St. Lawrence became its mission church. It became a separate church in 1890 and was renamed Our Lady of Good Counsel. The respected Baltimore architectural firm of Baldwin and Pennington was hired to design the church. The church, attached to the chapel, now serves as the church office and rectory. A parish school was built around 1890 to the north of the church. The current building, constructed in 1920, replaced the previous structure. The school building is currently being leased to Montessori. (WH.)

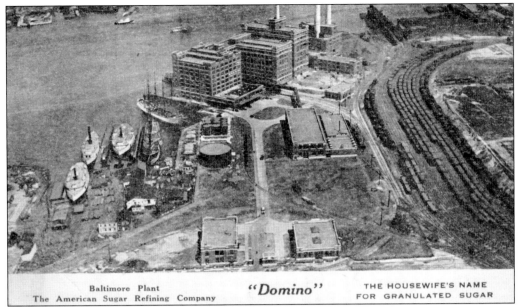

Baltimore Plant
The American Sugar Refining Company

"Domino"

THE HOUSEWIFE'S NAME
FOR GRANULATED SUGAR

DOMINO SUGAR PLANT, 1100 EAST KEY HIGHWAY (LOCUST POINT). Domino Sugar can trace its history to Colonial days. William Havemeyer, an English sugar refiner, came to New York in 1799 and, along with his brother, established the W. and F. C. Havemeyer Company. The name was changed in the late 1800s to Domino. By the 1930s, the company had expanded operations to five cities, including Baltimore. The famous neon sign atop the building is a familiar sight to those visiting the Inner Harbor. (WH.)

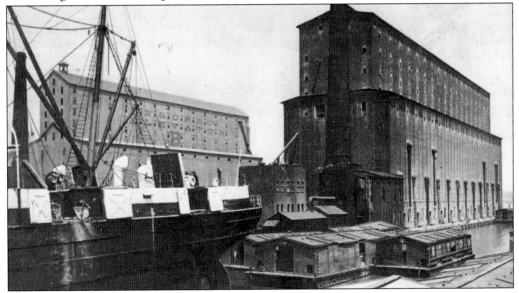

B&O GRAIN ELEVATORS, 1700 BEASON STREET (LOCUST POINT). Constructed in 1923, the B&O Railroad grain terminal was the biggest and fastest grain elevator in the world. Every year, nearly 10 miles of conveyor belt carried 3.8 million bushels of grain from railcars to transatlantic cargo ships. These vessels transported the grain to ports all over the world. The structure was placed on the National Register of Historic Places in 2004. Today the elevators have been converted into luxury waterfront condominiums (www.silopoint.com). (WH.)

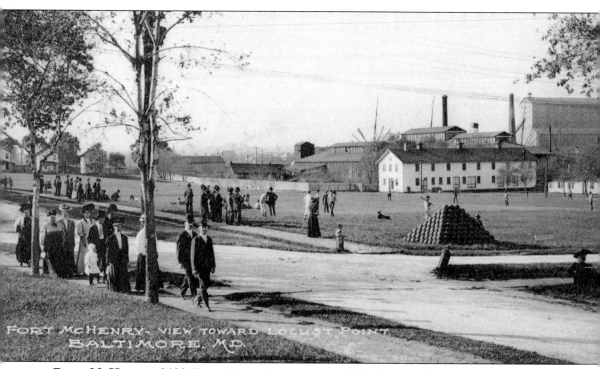

FORT MCHENRY, 2400 EAST FORT AVENUE, c. 1917 (LOCUST POINT). Threatened by war with either England or France, the people of Baltimore built a fort of earthen mounds with 18 guns in 1776. The Revolutionary War ended without an attack on Baltimore, but improvements to the fort continued. In 1798, plans were draw up for the star-shaped fort on the site today. James McHenry, a well-known politician, was instrumental in raising funds for the new fort, which was named in his honor. Fort McHenry became famous when the British tried to attack Baltimore during the War of 1812. The 25-hour bombardment by British war ships began September 13, 1814. The British were kept at bay, and the city was saved. Francis Scott Key, under British guard on an American truce ship, wrote the poem that immortalized the event, "The Star-Spangled Banner," later to become the national anthem. During the

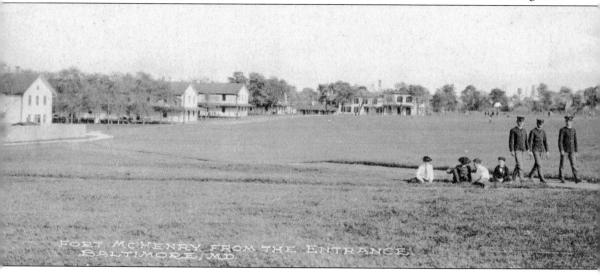

78

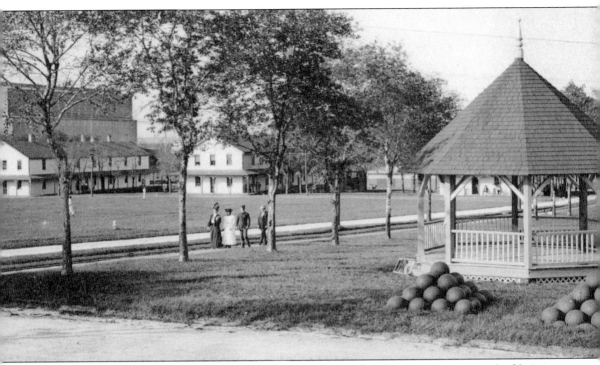

Civil War, Fort McHenry was used as a prison where political prisoners suspected of being Confederate sympathizers were held, often without trial. Many Confederate soldiers were imprisoned at the fort as well. In 1917, during World War I, the largest military hospital in the country was built here, with over 100 temporary structures to accommodate wounded American soldiers returning from the war in Europe. Those buildings can be seen in these two photographs. When the war ended, the need for the hospital slowly diminished, and in 1925, the temporary buildings were torn down. Fort McHenry became a national park, today administered by the National Park Service as the country's only National Monument and Historic Shrine (www.nps.gov/fomc). (WH.)

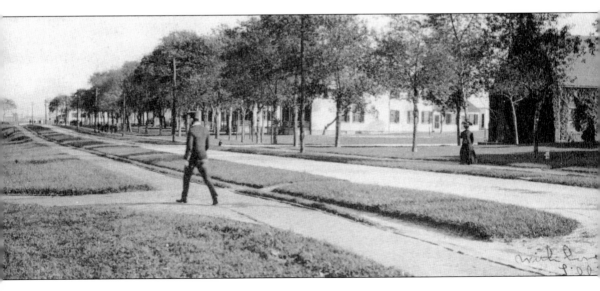

Deutsches Evangelisches Emigrantennaus,
1308-1312 Beason St., Locust Point, Baltimore, Md., U. S. A.

DEUTCHES EVANGELISCHES EMIGRANTENHAUS, 1308 BEASON STREET (LOCUST POINT).
Around 1887, the Evangelical Lutheran Church opened as Christ Church in Locust Point. The German Immigration House, seen here, was built next door. It was a receiving station for new arrivals debarking from the North German Lloyd Vessels (see page 81), which, until 1914, docked at the nearby B&O Railroad. Following World War I, the church converted the building into an Immigrants and Seamen's Home that operated under that name for another 40 years. Today the building is the Education Center for Christ Church. (WH.)

ENOCH PRATT FREE LIBRARY, BRANCH NO. 9, TOWSON AND BEASON STREETS (LOCUST POINT). This branch of the Enoch Pratt Free Library was opened in Locust Point in 1910 with funds donated by philanthropist Andrew Carnegie. In 1928, branch No. 9 was moved inside of the Francis Scott Key School (No. 76). In 1957, the branch was closed completely. The building seen in this photograph still stands today and is home to a commercial company. (WH.)

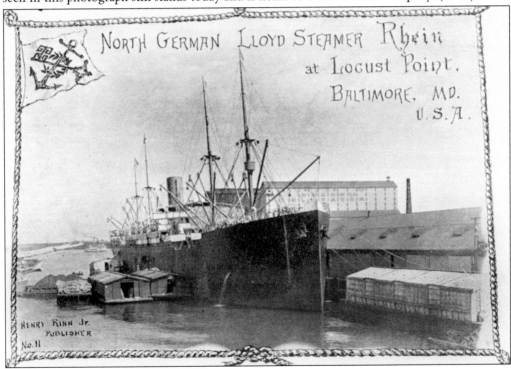

NORTH GERMAN LLOYD STEAMER *RHEIN* DOCKED AT THE B&O PIER (LOCUST POINT). The Norddeutscher Lloyd Steamer Company was founded in 1857 in Bremerhaven, Germany. Initially, it carried freight and passengers to England. In the spring of 1866, the line to Baltimore was established. According to old log books, the *Rhein*, seen in this photograph, made trips to Baltimore as early as 1890. The freighter brought many German immigrants to Baltimore during its years of service to Baltimore. The Lloyd Steamers discontinued service to Locust Point in 1914. (WH.)

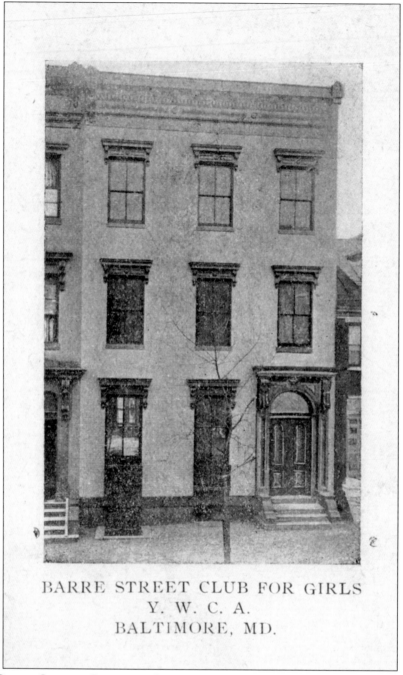

BARRE STREET CLUB FOR GIRLS
Y. W. C. A.
BALTIMORE, MD.

YWCA Barre Street Club for Girls, c. 1915 (Otterbein). This former residence, located at 129 West Barre Street, housed the YWCA's Club for Girls from 1913 to 1918. The YWCA was founded in 1883 to shelter and assist single young women entering the workforce in Baltimore City. Often coming from rural areas, these women faced harsh working and living conditions. Reflecting the times, a separate Colored YWCA was founded in 1896 to serve the same needs for African American women. In 1920, the two YWCAs merged after many years of mutual support. (WH.)

Six

THE SOUTHWEST
CARROLL PARK, EDMONDSON VILLAGE, FORREST PARK, GWYNNS FALLS, HARLEM PARK, HUNTING RIDGE, IRVINGTON, MILL HILL, ST. AGNES, TEN HILLS, WALBROOK

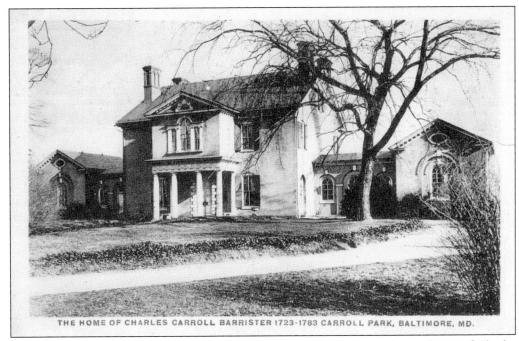

THE HOME OF CHARLES CARROLL BARRISTER 1723-1783 CARROLL PARK, BALTIMORE, MD.

MOUNT CLARE MANSION (CARROLL PARK). Mount Clare was the former home of Charles Carroll the Barrister (1723–1783). He was a delegate to the Continental Congress and served on the first state senate of Maryland. Construction of the summer home began in 1756. It was named after his grandmother and sister, both named Mary Clare. At the time, the home had a view of the Patapsco River a mile away. After being passed down through the family, the home and the remaining land were sold to the city in 1890 for use as a public park. Mount Clare is on the National Register of Historic Places and open to the public (www.mountclare.org). (WH.)

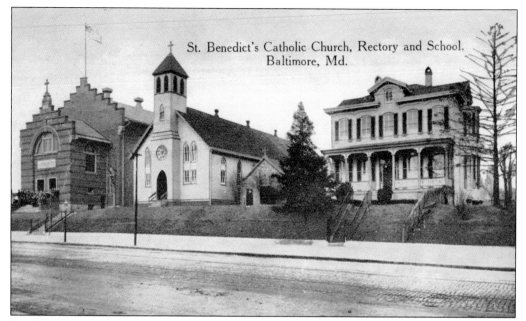

ST. BENEDICT'S CATHOLIC CHURCH, RECTORY, SCHOOL, AND GROTTO OF LOURDES, 2618 WILKENS AVENUE (MILL HILL). St. Benedict Parish was established in 1893 and staffed by Benedictine monks from St. Vincent Archabbey. German Catholics, employed in the Wilkens family businesses, constructed the small frame church in the center of this photograph. The church bell was from Hook and Ladder Company No. 5, where it was removed from its tower at the company's Aisquith Street firehouse and presented to the church. By the 1920s, the brick church to the left was built to accommodate the growing congregation, and the original church was used as the rectory. In 1931, the structures seen here were razed and the current church was constructed (www.saintbenedict.org). (WH.)

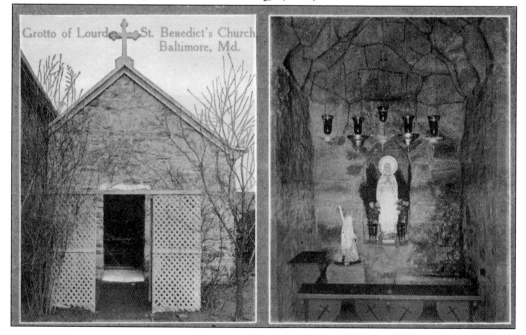

ROGERS MEMORIAL METHODIST CHURCH, BOYS' BRIGADE COMPANY G, 2ND MARYLAND REGIMENT, 1305 WASHINGTON BOULEVARD, C. 1908 (CARROLL PARK). In 1883, the Boys' Brigade was founded by William Smith. The brigades were church-sponsored. The boys would do military drills and study the Bible. The uniforms consisted of forage (pillbox) caps cocked jauntily over the right ear, a white linen haversack that was more ornamental than useful, and a leather belt with a buckle showing the "B.B." anchor symbol. Rogers Memorial Church is now Wayman's Memorial AME Church. (WH.)

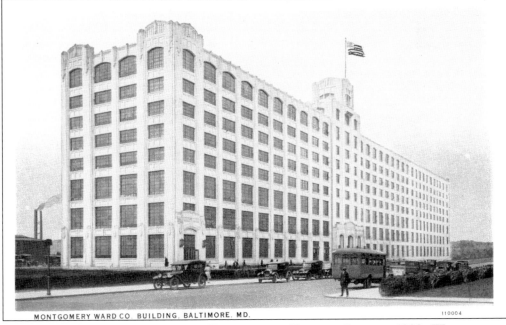

MONTGOMERY WARD CATALOG HOUSE AND RETAIL STORE, 1800 WASHINGTON BOULEVARD, C. 1925 (CARROLL PARK). Montgomery Ward was Baltimore's largest mercantile building and the city's first suburban department store when it opened on August 1, 1925. The art deco building was designed by in-house engineer of construction W. H. McCaully. After Ward opened, mail receipts in Baltimore increased by 10 percent. The U.S. Postal Service gave the company its own zip code. Today the building houses office space (www.montgomerypark.com). (WH.)

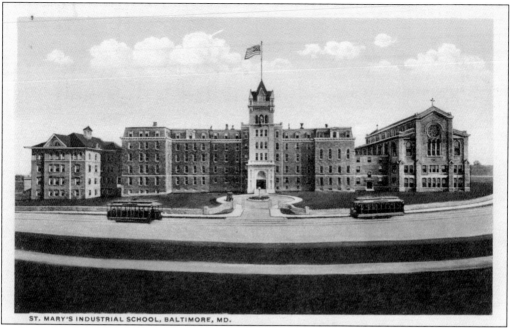

ST. MARY'S INDUSTRIAL SCHOOL, BALTIMORE, MD.

MAIN ALTAR, CARDINAL GIBBONS JUBILEE MEMORIAL CHAPEL,
ST. MARY'S INDUSTRIAL SCHOOL, BALTIMORE, MD.
Main Altar, Side Altars and Statues executed in Carrara Marble, by
Daprato Statuary Company. Chicago - New York - Pietrasanta, Italy.

ST. MARY'S INDUSTRIAL SCHOOL AND CHAPEL ALTER, 3225 WILKENS AVENUE (ST. AGNES). In 1866, Archbishop Martin J. Spalding felt that Baltimore needed a charity school for boys. He asked the Xaverian Brothers, who were running similar schools in Belgium, to run such a school in Baltimore. Emily Carroll McTavish (1793–1867), granddaughter of Charles Carroll of Carrollton, died shortly after and left 100 acres of land to the Archdiocese of Baltimore on which St. Mary's Industrial School was built. In the course of St. Mary's 82 years of operation, it housed over 20,000 boys, some orphans, some simply committed by their families, or those deemed by the civil authority as "incorrigible." By 1868, the five-story granite structure was far enough completed to allow for partial occupation. In 1919, the original building and an 1878 wing were destroyed by fire. A fund-raising campaign, spearheaded by alumnus Babe Ruth, funded the construction of a new, smaller school opened in 1922. (WH.)

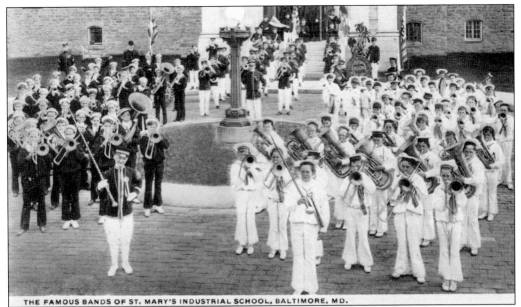

THE FAMOUS BANDS OF ST. MARY'S INDUSTRIAL SCHOOL, BALTIMORE, MD.

ST. MARY'S INDUSTRIAL SCHOOL BANDS (ST. AGNES). After reopening in 1922, the school found the need for its services diminishing. The state was assuming more and more responsibility for the young men. The final blow came in 1950, when the state transferred all its wards at St. Mary's to the Maryland Training School for Boys. The state did not find fault with St. Mary's. Rather, its concern was the fear of lawsuit because of the law requiring a division between church and state. Since 1880, St. Mary's had received an annual grant. The school closed in 1950, reopened in 1961 as Cardinal Gibbons School, and is open today educating boys. The handwritten note on the reverse of the card below reads, "Dear Father, Here is the best Band I Ever Heard. It sure is a neat out-fit for boys. Good-by. From, Pvt. H. C. Ritter" to Cloyd Ritter, Lewistown Junction, Mifflin County, Pennsylvania (www.cardinalgibbons.com). (WH.)

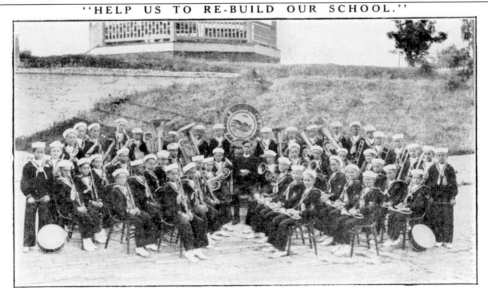

"HELP US TO RE-BUILD OUR SCHOOL."

ST. MARY'S INDUSTRIAL SCHOOL BAND, BALTIMORE, MD.
These 49 boys with their leader, Bro. Simon, played in Cleveland, Detroit, Chicago, St. Louis, Indianapolis, Baltimore, New York and Philadelphia, September 8 to 30, as "Babe" Ruth's Band.

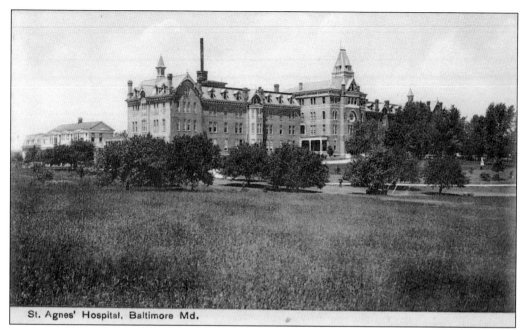

St. Agnes' Hospital, Baltimore Md.

ST. AGNES HOSPITAL, 900 SOUTH CATON AVENUE (ST. AGNES). The hospital was originally founded in 1863, under the name Baltimore Infirmary, by the Daughters of Charity to provide nursing care for the poor. The first hospital was located near Greenmount Cemetery. In 1875, it moved to Caton Avenue, which was considered to be a healthier climate. In 1906, the name was changed to reflect the full-service hospital it became. The French Gothic–style hospital was razed in the 1950s to make room for a new, larger facility (www.stagnes.org). (WH.)

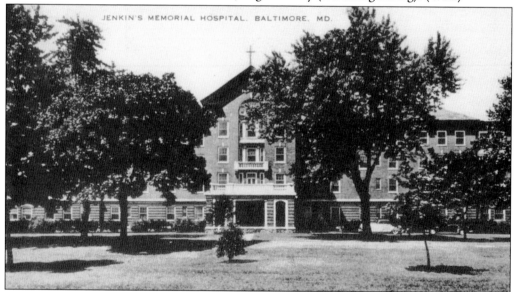

JENKIN'S MEMORIAL HOSPITAL, BALTIMORE, MD.

JENKINS MEMORIAL, 3320 BENSON AVENUE (ST. AGNES). In 1927, with a bequest from Elizabeth Jenkins, the Jenkins Memorial Hospital was established. The Daughters of Charity were wards of the hospital, with Catholic Charities taking over operations in 1989. Today it continues to be a senior care facility under the name Jenkins Memorial Nursing Home. (WH.)

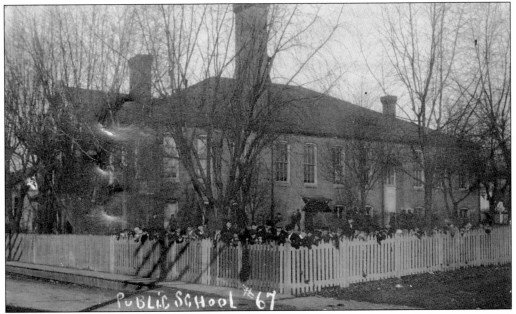

PUBLIC SCHOOL NO. 67, OLD FREDERICK ROAD AND McCURLEY STREET, C. 1914 (IRVINGTON). In 1872, Baltimore Public Schools built a one-story schoolhouse. In 1892, the building was reconditioned and the second floor was added. By 1925, the population had outgrown the school and a new one was built at 4000 Old Frederick Road. But that was not the end for old No. 67. It was renumbered 71A and continued to function as a school. By the 1950s, it was abandoned and replaced with Sarah M. Roach Elementary School. (WH.)

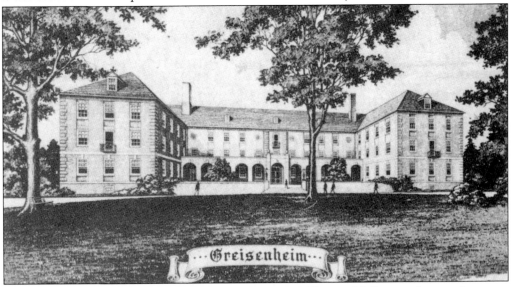

GREISENHEIM—GENERAL GERMAN AGED PEOPLES' HOME, 22 SOUTH ATHOL AVENUE, C. 1935 (IRVINGTON). In 1881, a group of Baltimoreans of German ancestry decided to establish a home for aged Germans. The first home was built on Lombard Street. In 1885, the home moved to a larger facility on Baltimore Street. Once again, by 1935, the need for a larger structure became necessary and the home seen in this image was built. Today it is owned by Future Care and continues to care for elderly of any descent. (WH.)

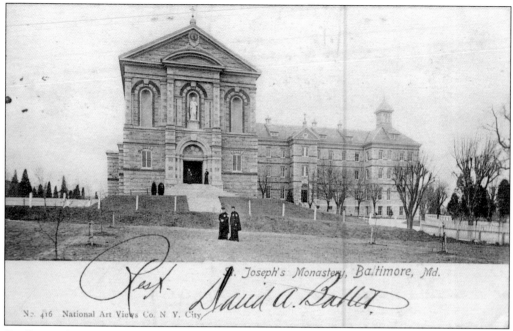

St. Joseph's Monastery, Baltimore, Md.

No. 416 National Art Views Co. N. Y. City

ST. JOSEPH'S MONASTERY, 3800 FREDERICK AVENUE, C. 1914 (IRVINGTON). St. Joseph's Monastery was founded by the order of the Passionist Fathers in 1865. The original monastery was built in 1867 but was lost to fire and replaced in 1886 with the monastery above. In 1883, St. Joseph's Church was constructed on the grounds to accommodate 600 people, more than the chapel at the monastery could. In 1932, the current church was built and is used by parishioners today. The monastery closed in the mid-1980s from lack of funds and personnel, and the building became home to a drug rehabilitation center (www.stjosephsmonasteryparish. org). (WH.)

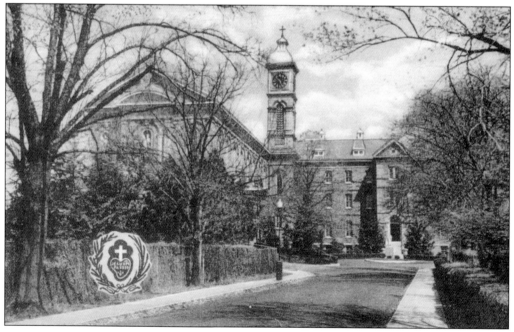

THE MIRACLE

ST. JOSEPH'S MONASTERY PASSION PLAY (C. 1914) AND CONVENT (IRVINGTON). The monastery, for many years, hosted an annual Passion Play, the story of the death of Jesus Christ and his resurrection, performed by the Veronica's Veil Players. The plays were held in the school's hall. Veronica's Veil Players was founded by two Passionist priests in 1910 in Pittsburgh, Pennsylvania. It then moved on to Union City, New Jersey; Baltimore, Maryland; and Dunkirk, New York, cities where the Passionist Fathers had monasteries and parishes. The plays were performed every Sunday during Lent. Today the Pittsburgh company of Veronica's Veil Players still performs every Lent (veronicasveilplayers.org). Below is an image of the convent, built in 1923 adjacent to the school. It was home to the School Sisters of Notre Dame, who staffed the now defunct school. Today the convent is used as the rectory and home of the Passionists. (WH.)

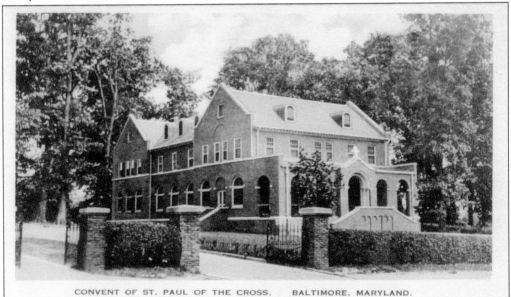

CONVENT OF ST. PAUL OF THE CROSS. BALTIMORE, MARYLAND.

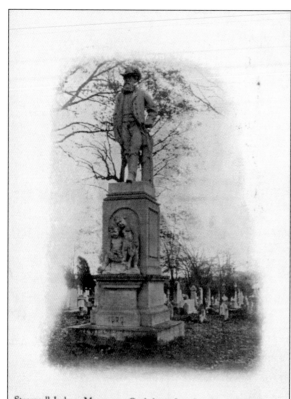

Stonewall Jackson Monument, Confederate Lot, Loudon Park Cemetery.

LOUDON PARK CEMETERY, STONEWALL JACKSON MONUMENT, AND MAUSOLEUM, C. 1907, 3801 FREDERICK AVENUE (IRVINGTON). Loudon Park Cemetery was founded in 1853, created out of James Carey's estate, Loudon Farms. It is the largest nonsectarian cemetery in Baltimore. The monument to Stonewall Jackson, created by renowned sculptor Frederick Volck, sits atop Confederate Hill. The monument was erected in 1870 by the Loudon Park Confederate Memorial Association. In 1871, a group of veterans formed the Society of the Army and Navy of the Confederate States in Maryland. Their first action was to return Maryland bodies from other states. There are about 650 Confederate and 2,300 Union soldiers buried at Loudon. Some people of notoriety buried at Loudon are Mary Pickersgill, H. L. Mencken, and Jerome Bonaparte. Below is the old chapel mausoleum, section DD, covered in ivy. Today it is in ruins (www.loudon-park.com). (WH.)

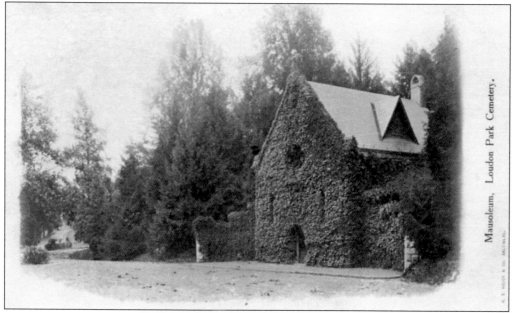

Mausoleum, Loudon Park Cemetery.

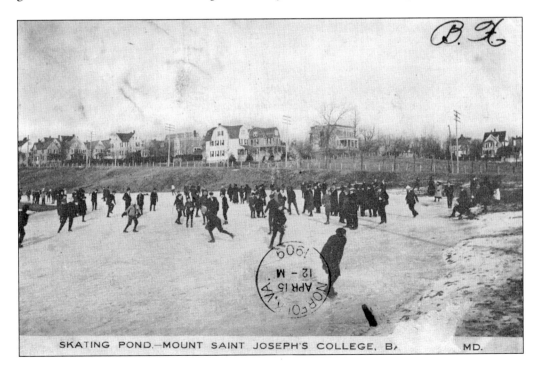

MOUNT ST. JOSEPH'S COLLEGE, 4400 FREDERICK AVENUE (IRVINGTON). Mount St. Joseph's College was founded in 1873 by Xavarian Brothers' novitiate on the site of the Lusby estate. In 1901, the "M" building, seen on the postcard above, was dedicated. The tower is all the remains of the building today. The Xavarian Brothers' reside in the Lusby mansion on the campus. Below are students skating on the pond located where the football field is today. Many long-gone houses can be seen in the background along Yale Avenue (www.msjnet.edu). (WH.)

SKATING POND.—MOUNT SAINT JOSEPH'S COLLEGE, B, MD.

Chapelgate Lane

NE OF THE SIX "ENTRANCES" FROM THE ELLICOTT CITY CAR-LINE

CHAPELGATE LANE, C. 1911 (TEN HILLS). The Ten Hills community was incorporated in 1911 on the old A. S. Chappel Estate, remembered in the naming of Chapelgate Lane. This postcard was sent to prospective buyers of the community of Ten Hills. The reverse, in part, reads, "These 100-foot-front lots are over twice as large as the usual suburban lot, yet cost no more! . . . 50-foot-wide macadam streets, following contour of the hills; inspiring 20-mile view of harbor and horizon." (WH.)

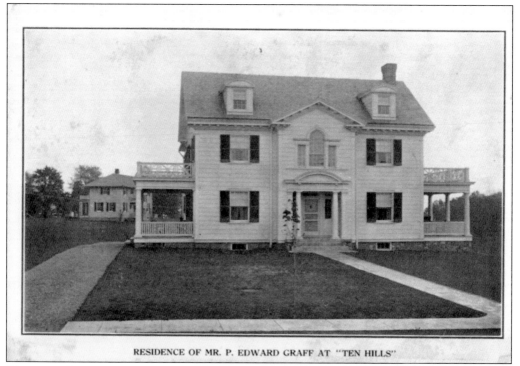

RESIDENCE OF MR. P. EDWARD GRAFF AT "TEN HILLS"

HOME OF P. EDWARD GRAFF, 5003 EDMONDSON AVENUE (TEN HILLS). Graff does not seem to have left much of a paper trail, but his home speaks for itself in its Colonial style. The reverse, in part, reads, "½ acre lots—$1280 up. . . . It is the land that increases in value— not the house. Compare the present price (10¢ a square foot) of these lots with any other location." The home still stands, and the right side porches have been enclosed. (WH.)

94

HOME OF CHARLES HENRY STEFFEY (1883–1958), 502 CHAPELGATE LANE, C. 1911 (TEN HILLS). This is the home of the developer of the community of Ten Hills. He was the president of the firm bearing his name and in business for 40 years. Besides Ten Hills, he was responsible for the development of the communities of Anneslie, Oak Crest, and Hillcrest. Steffey was one of the original members of the state real estate commission and was instrumental in the building of nearby St. Bartholomew's Church. (WH.)

512 OLD ORCHARD ROAD, WILLIAM HUNDERFORD PONDER (1885–1959) (TEN HILLS). Ponder worked for 50 years at McDowell-Pyle Confectionery Company, his wife Lula's family business. He was the president of the company before retiring. Ponder is a descendant of Delaware governor James Ponder (1819–1897). The 1920 U.S. Census records show that the Ponders' eldest child, William, was born while they lived in Ten Hills. Records also show a live-in Hungarian servant named Rosa Romanov. By 1930, the family was living on University Parkway with a second child named Mary Lou. (WH.)

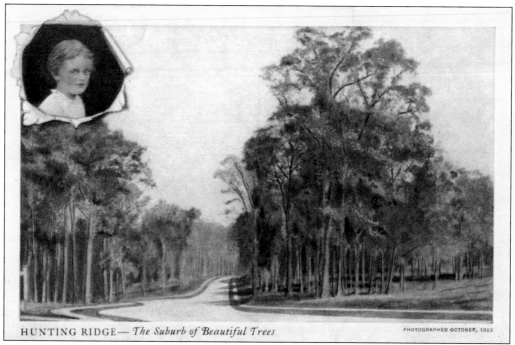

HUNTING RIDGE — *The Suburb of Beautiful Trees* PHOTOGRAPHED OCTOBER, 1923

HUNTING RIDGE, A SUBURB OF BEAUTIFUL TREES (HUNTING RIDGE). The community of Hunting Ridge was incorporated in 1923. The image on this postcard is an artist's rendering of the intersection of Winans Way and Brinkwood Road before development. The reverse reads, in part, "is on Edmondson Avenue opposite of Ten Hills . . . with high elevation and restrictions, making it an excellent place particularly for those who have children." (MWW.)

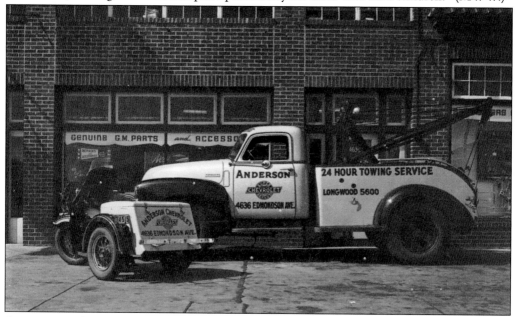

ANDERSON CHEVROLET, 4636 EDMONDSON AVENUE (HUNTING RIDGE). Anderson Chevrolet was located on the site now occupied by the Hunting Ridge Presbyterian Church parking lot (www.andersonautomotive.com). (WH.)

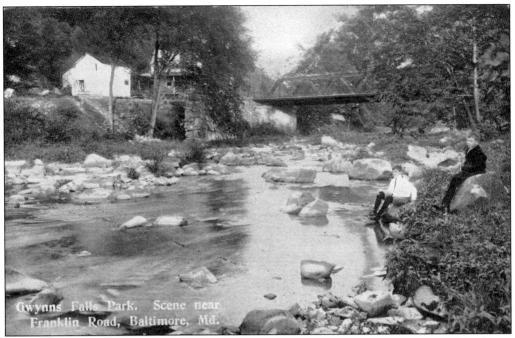

Gwynns Falls Park. Scene near Franklin Road, Baltimore, Md.

GWYNNS FALLS. Pictured above around 1905, Gwynns Falls Park, near Franklin Road, was originally conceived as a stream valley park by the Olmsted brothers in their 1904 Plan for the City of Baltimore. The Gwynns Falls and Dead Run streams, which are located within the park, originally powered mills that produced grain, paper, and textiles. The area included an old mill race later filled to create a path. The park and its trails are still open to the public today (www.gwynnsfallstrail.org). Below is Gwynn Falls Park Junior High, seen here around 1946. Located on Hilton and Morley Streets, the building still stands today. (WH.)

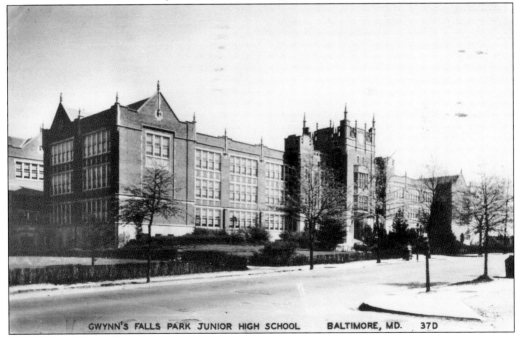

GWYNN'S FALLS PARK JUNIOR HIGH SCHOOL BALTIMORE, MD. 37D

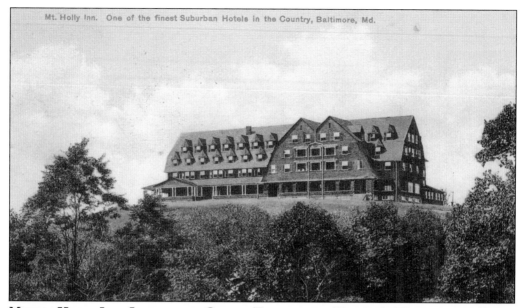

MOUNT HOLLY INN, LOBBY, AND OFFICE (EDMONDSON VILLAGE). The Mount Holly Inn was originally built in 1900 by developer Daniel W. Dwyer (born 1859) and designed by the Baltimore architectural firm of Wyatt and Nolting. Before opening, the large suburban hotel burned to the ground on June 3, 1900, forcing Dwyer into bankruptcy. His creditors sold what remained to James L. Filon (1849–1909), who thriftily rebuilt the Wyatt and Nolting design. In 1902, the hotel's 120 rooms were opened to the relief of scores of Baltimoreans fleeing the summer heat of downtown. Filon operated the hotel every summer through his death, and his widow then kept it going through 1913, but the mammoth structure stood empty during World War I. It then was purchased by Winfield S. Cahill (1861–1945) in 1918 and turned into a year-round enterprise. On December 7, 1920, the building once again caught fire. Cahill did not rebuild. (WH.)

MT. HOLLY INN, BALTIMORE, MD. THE LOBBY AND OFFICE

MT. HOLLY INN, BALTIMORE, MD. A THREE ROOM APARTMENT

MOUNT HOLLY INN THREE-ROOM APARTMENT AND BALLROOM (EDMONDSON VILLAGE).
After the 1920 fire, Winfield Cahill sold off all but 5.5 acres of the grounds to developers and turned a building that had served as the original hotel's stables into a roadhouse. This operated until 1939, when Cahill unexpectedly announced both its closure and his presentation of the land and buildings to the City of Baltimore for recreational purposes. The land was incorporated into the adjacent Gwynns Falls Park. The old hotel stables/roadhouse building was turned into the W. S. Cahill Recreation Center and as such served its neighborhood until it was set afire by one of its clients in 1969. The Edgewood Recreation Center was built in 2005 at 835 Allendale Street. (WH.)

MT. HOLLY INN, BALTIMORE, MD. THE BALL ROOM

99

LASTING PAINT PRODUCTS COMPANY ADVERTISEMENT, 1400 MORELAND AVENUE (WALBROOK). The reverse reads, "It Was Just an Old Dwelling. Now Thousands Admire It! Few people passing by this beautiful residence would ever realize that a few weeks ago it was only an ordinary frame dwelling. It has recently been covered with EVERLASTSTONE INDESTRUCTIBLE STUCCO." The house has since been demolished, and Blue Ridge Fuel Corporation owns the commercial building on the site. (MWW.)

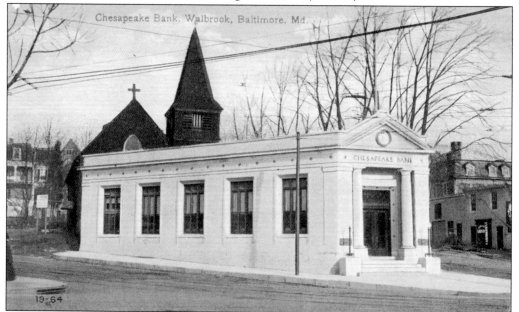

CHESAPEAKE BANK, 3200 WEST NORTH AVENUE (WALBROOK). Chesapeake Bank of Maryland opened in 1911. The Walbrook Junction branch is seen in this photograph. In the 1940s, the bank had some excitement when it was robbed. In the 1960s, Union Trust Bank had a branch at this location. Today Wachovia Bank occupies the space. Banks may come and go, not to mention merge, but this building continues to serve its original purpose. (WH.)

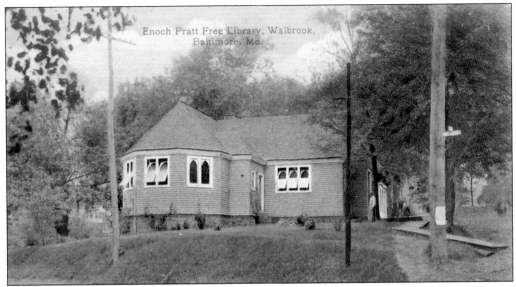

ENOCH PRATT FREE LIBRARY, WALBROOK BRANCH, HILTON STREET AND CLIFTON AVENUE (C. 1910) (WALBROOK). In 1907, the Enoch Pratt Free Library opened branch No. 8 in the old Walbrook Presbyterian Church. People often were unable to find the library because they mistook it for a church. In 1921, an L-shaped addition was added. In 1957, the current branch was built at 3203 West North Avenue and the old one demolished. (WH.)

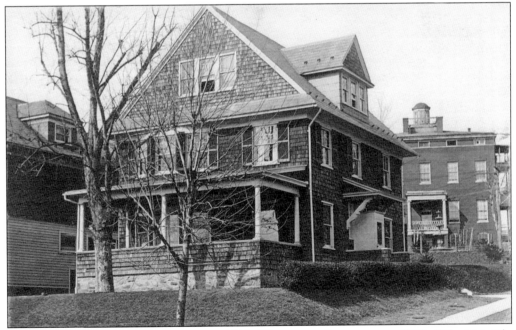

HOME OF ALFRED H. BURNHAM, 3300 WINDSOR AVENUE, C. 1913 (WALBROOK). According to 1920 U.S. census records, Burnham (born 1873), a native of Connecticut, lived here with his wife, Minnie, their children Alfred Jr., Francis, Josephine, and Lydia, and Minnie's mother, Harriett Simmons. Burnham worked in the cotton manufacturing industry. The house remains a private residence. Its cedar shingles have been covered or replaced with vinyl siding. A corner of Epiphany College (see page 102) can be seen at the rear of the home. (WH.)

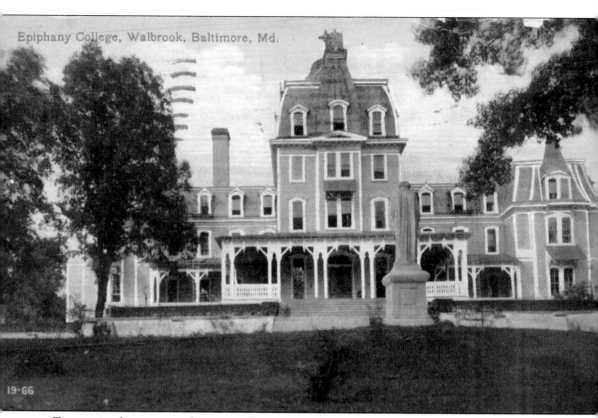

Epiphany College, Walbrook, Baltimore, Md.

19-66

EPIPHANY APOSTOLIC COLLEGE, PIEDMONT AVENUE AND ALLENDALE ROAD, C. 1919 (WALBROOK). In 1874, the Highland Park Hotel opened its doors. Joseph Pearson (born 1784) built a hotel and 40 villas on the site. Pearson sold the retreat to lawyer Charles G. Wilson, who built a horsecar line—the Baltimore and Randallstown Railroad—to connect his property to Baltimore City. The hotel closed a year later. In the late 1880s, the hotel building was acquired by the Franciscan Sisters of Mill Hill. In 1889, the Sisters moved out and the Franciscan Fathers opened the Epiphany Apostolic College as a preparatory school for St. Joseph's Seminary, where young men were trained to carry on work among the African Americans of the United States. Rev. Charles Randolph Uncles (born 1859), a student at the college, was the first African American ordained a Roman Catholic priest in the United States. The college remained at this site until 1925, when it moved to Newburgh, New York. The property was sold and the school demolished shortly after. (MWW.)

Seven

THE WEST
COPPIN HEIGHTS, DRUID HILL, FRANKLIN SQUARE, HARLEM PARK, LAFAYETTE SQUARE, PENN NORTH

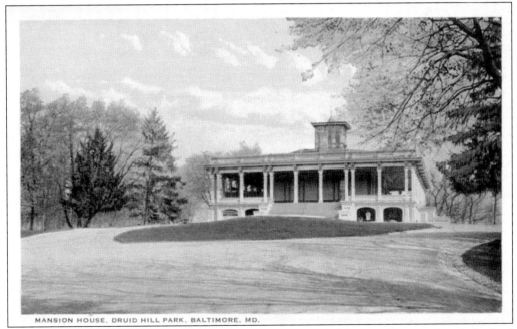

MANSION HOUSE, DRUID HILL PARK, BALTIMORE, MD.

DRUID HILL PARK MANSION HOUSE (DRUID HILL). Baltimore City purchased the land for the park in 1860, making it the first large municipal park in the city. The park land was purchased from the Rogers family, who had owned it for generations. The first Rogers home, described as a palace, sat where the Mansion House is currently located. The Mansion House replaced the palace, built sometime prior to 1869, which were both lost to fire. The building serves as the Maryland Zoo's administration office today (www.marylandzoo.com. (WH.)

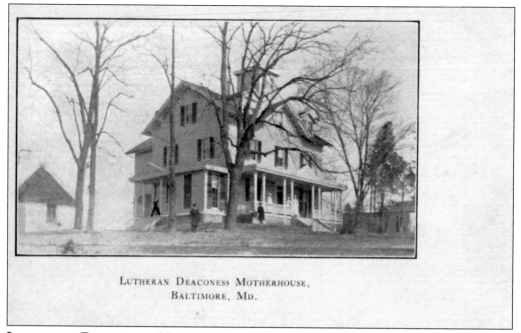

LUTHERAN DEACONESS MOTHERHOUSE,
BALTIMORE, MD.

LUTHERAN DEACONESS MOTHERHOUSES, 2500 WEST NORTH AVENUE (COPPIN HEIGHTS). In 1885, the Lutheran Synod established an Order of Deaconesses. "The power of American women to work for Christ" was recognized. In 1895, Baltimore was chosen as the headquarters for the Motherhouse where the deaconesses were trained. Their first home was on Fulton Avenue. In 1901, the Becker property, current location of the Coppin State University campus, was purchased. The home seen above was the former summer house of Justice Roger B. Taney (1836–1864). Dedicated in 1911, the new, grand Deaconess Motherhouse, seen below, was built upon the site of the old house. (Above WH; below MWW.)

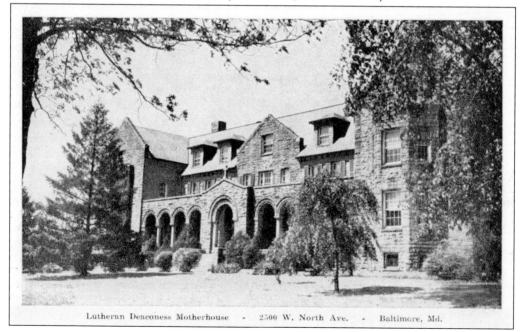

Lutheran Deaconess Motherhouse - 2500 W. North Ave. - Baltimore, Md.

LUTHERAN DEACONESS MOTHERHOUSE LOGGIA AND SISTERS PARLOR, 2500 WEST NORTH AVENUE (COPPIN HEIGHTS). The 1911 Motherhouse was now large enough to extend training to young women who wished to prepare themselves for Christian service without becoming deaconesses by providing a one-year course. In 1922, the course was expanded to a two-year curriculum. In 1931, they expanded by purchasing a school and cottage on Warwick Avenue, adjoining the property. The deaconesses were now able to offer a Christian kindergarten to local children. The Motherhouse remained at this site until 1952, when it moved to 6901 North Charles Street. The old Motherhouse is used today as an administration building of Coppin University. (Above MWW; below WH.)

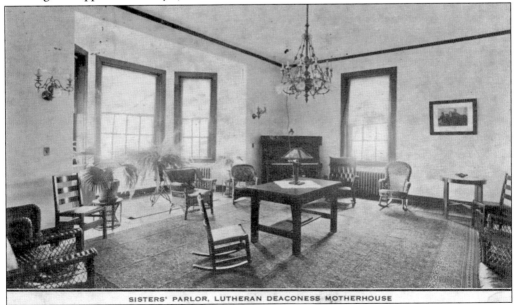

SISTERS' PARLOR, LUTHERAN DEACONESS MOTHERHOUSE

ALICE MAY YOUSE
Shaftesbury College of Expression
14 North Carey Street
Baltimore

ALICE MAY YOUSE (1863–1938), SHAFTESBURY COLLEGE OF EXPRESSION, 14 NORTH CAREY STREET (FRANKLIN SQUARE). Alice May Youse was an actress, teacher, and poet. She appeared in silent films with Lon Chaney—*The Place beyond the Winds* in 1916 and *Fires of Rebellion* in 1917. She ran a school of "elocution" in her home. The Shaftesbury College closed in 1930. Her sisters remained in the house after her death until 1954. The 17-room mansion was divided into apartments. Today it is home to an air-conditioning company. (WH.)

ROHRBACH'S CAFÉ, 1307 WEST BALTIMORE STREET (FRANKLIN SQUARE). Rohrbach's Café was a saloon and café owned by Adam Rohrbach (1874–1919) from around 1900 until his death. His wife, Fredericka Charlotte Rohrbach, is listed as the proprietor in the 1920 Baltimore City Directory. Adam Rohrbach's occupation in the 1890 U.S. Census lists him as a waiter. Perhaps he used the time as on-the-job training while saving to open his own restaurant. (WH.)

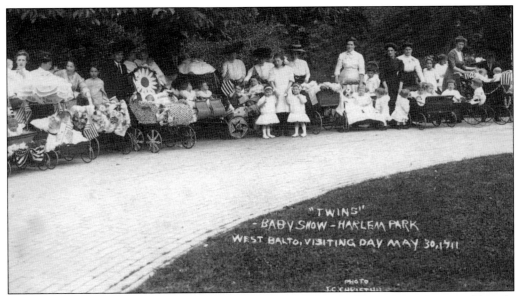

TWINS BABY SHOW, HARLEM PARK, VISITING DAY, MAY 30, 1911 (HARLEM PARK).
The twins in the photograph were paraded about Harlem Park during the 1911 Memorial Day celebrations. Note the American flags and bunting decorating the baby carriages right down to the spokes on the wheels. Having surviving twins was something to celebrate. The single-birth mortality rate for 1911 was 124 babies per 1,000 died (the 2008 rate is 6.3 per 1,000). Twin mortality rates are five times higher, meaning that less than half of the twins born in 1911 survived infancy. (WH.)

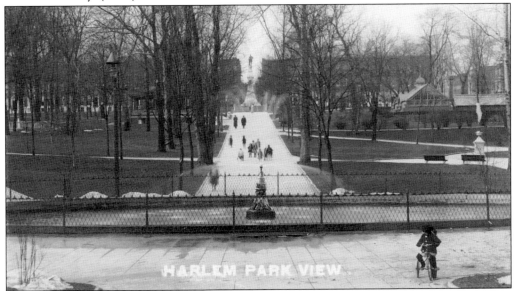

HARLEM PARK (HARLEM PARK). Harlem Park was originally a 31-acre tract known as Chatsworth. By 1818, the land belonged to Thomas Edmondson (1765–1836), who built his estate on it. His descendants sold much of the land for subdivision, and a portion was donated for use as a park. The greenhouse seen at right center may have been from the 1872 estate. The James Ridgley monument can be seen in the background. Today the park serves as a playground for the local school and is not open to the public. (WH.)

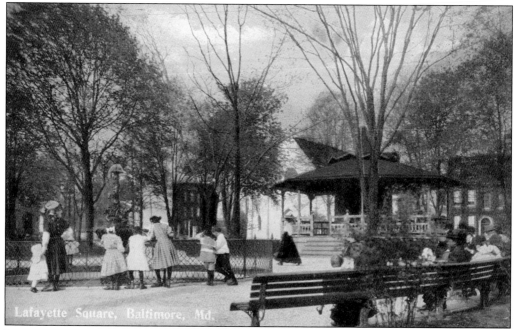

LAFAYETTE SQUARE (LAFAYETTE SQUARE). Developers of the estate of William Lorman (1764–1841) sold 3 acres to the city in 1857 on the understanding that the streets surrounding it would be paved and the land used as a public park. The city paved the streets but then was obliged to turn the land over to the U.S. government during the Civil War to be used as Camp Hoffman, a recruiting center for Maryland and Delaware Volunteers. Today it is open to the public. (WH.)

STATE NORMAL SCHOOL, LAFAYETTE AND CARROLLTON STREETS (LAFAYETTE SQUARE). The State Normal School was established in 1865 for the purpose of educating teachers for the public schools. In 1874, the structure in this photograph was built. The auditorium could accommodate 600 people. Each county was allowed to send two students for every resident. The school moved in 1915 to Towson, Maryland, and became Towson State University. The school was used as a public school until it was demolished in 1976 (www.towson.edu). (WH.)

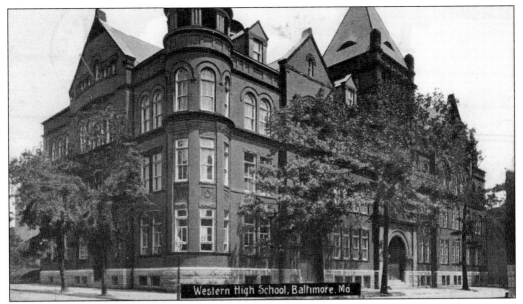

Western High School, Baltimore, Md.

WESTERN HIGH SCHOOL, LAFAYETTE AVENUE AND MCCULLOH STREET (LAFAYETTE SQUARE). Baltimore was one of the first public school districts to recognize that females needed the same higher education as males. In 1844, Baltimore City Public Schools made a decision to build two public schools dedicated to the teaching of girls. Thus, Eastern and Western schools were built in their respective locations in the city. It was deemed necessary to build two schools because "females were more delicate than males" and needed to attend school close to home. Western High School was built in 1896, and the school remained here until 1925. The building still stands today. (MWW.)

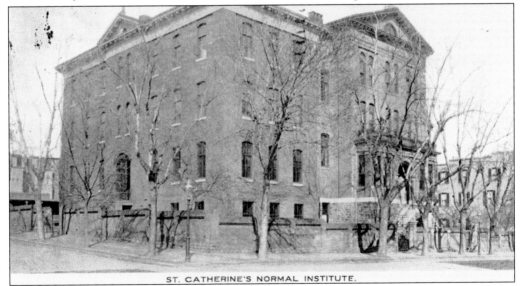

ST. CATHERINE'S NORMAL INSTITUTE.

ST. CATHERINE'S NORMAL SCHOOL, 701 NORTH ARLINGTON AVENUE (LAFAYETTE SQUARE). Built in 1875, St. Catherine's was the first school for teachers in Catholic schools. The architect was E. Francis Baldwin. The academy was run by the Sisters of the Holy Cross. Around 1928, the school moved. In the 1950s, St. Pius V Church used it as a parish school. The school closed in the 1960s and was turned into the Carroll Manor assisted living facility. In 1978, the school was demolished and a new facility was built in its place. (WH.)

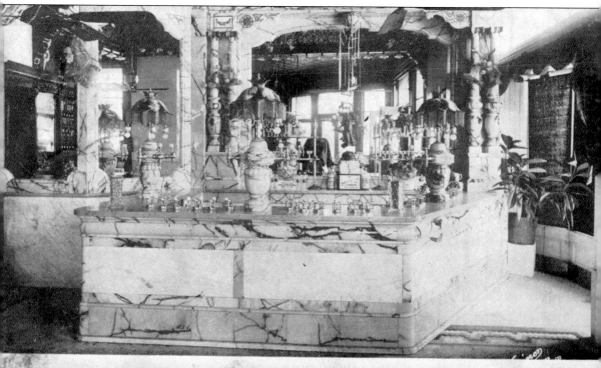

THE SCHANZE SODA WATER FOUNTAIN, PENNSYLVANIA AND NORTH AVENUES, BALTIMORE, MD.

Come have a drink? You know.

SCHANZE'S PHARMACY SODA WATER FOUNTAIN, 2424 PENNSYLVANIA AVENUE, C. 1910 (PENN NORTH). Dr. Frederick W. Schanze (1868–1944) owned one of the oldest pharmacies in Baltimore. The stunning, all marble fountain was the focal point of his store. It surely attracted the patrons of his theater next door at 2426 Pennsylvania Avenue. The Schanze's Theater operated from 1912 to 1949, showing vaudeville acts and movies. Marble was used in the facade of the theater. Both buildings still stand. The old theater building belongs to the Arch Social Club today. (MWW.)

Eight

THE NORTHWEST
CLYBURN, FOREST PARK,
HOWARD PARK, PARK HEIGHTS,
PARK CIRCLE, PIMLICO, WEST
ARLINGTON, WOODMERE

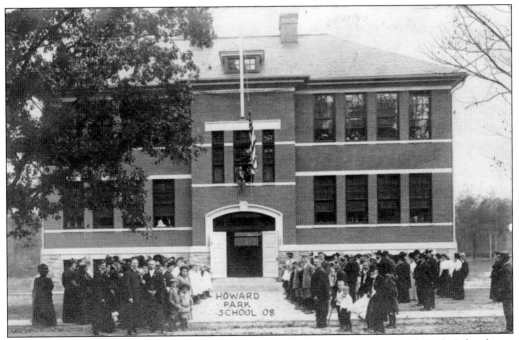

HOWARD PARK SCHOOL NO. 218 IN 1908 (HOWARD PARK). Howard Park School was built in 1907 but was not open to students until 1908. By 1908, over 300 families called the neighborhood home, and thus a school was needed. In 1958, the Howard Park Recreation Center was built adjacent to the school. (WH.)

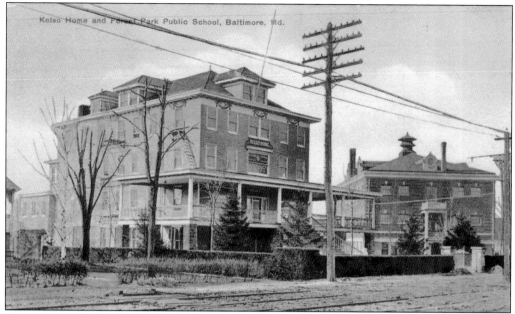

KELSO HOME FOR ORPHANS OF THE METHODIST EPISCOPAL CHURCH (FOREST PARK).
The Kelso Home was founded in 1873 by Thomas Kelso (1784–1878), an Irish immigrant. To be eligible to attend, girls had to be 4 to 17 years old and at least one parent must have been a member of a Methodist Episcopal church. Once a parent or relative committed a child, they could not take them back until they were released at age 18. The school was at this location from 1903 to 1925, when it moved to its current location in Towson. (MWW.)

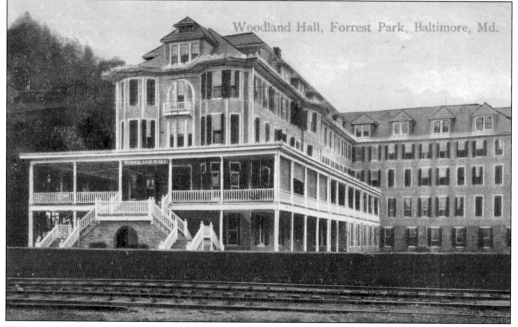

WOODLAND HALL, GARRISON BOULEVARD AND WOODLAND AVENUE (CLYBURN).
Woodlawn Hall was built in 1902. It replaced the Forest Inn. Like so many of Baltimore's suburban resorts and hotels, it was destroyed by fire on November 17, 1918. (MWW.)

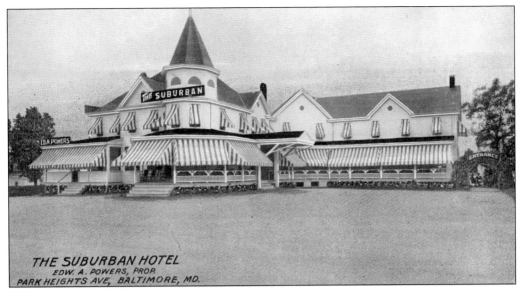

THE SUBURBAN HOTEL
EDW. A. POWERS, PROR
PARK HEIGHTS AVE, BALTIMORE, MD.

THE SUBURBAN HOTEL, 4502 PARK HEIGHTS AVENUE (PARK HEIGHTS). In the late 1880s, Egbert G. Halstead (born 1838) built the Pimlico Hotel, catering to those traveling to or from the racetrack. It was commonly referred to as Halstead's Hotel. In 1905, the hotel was sold to Edward A. Powers, who renamed it the Suburban Hotel. In 1909, the building was sold to the Archdiocese of Baltimore, who demolished the hotel and constructed St. Ambrose Church and convent on the site. (WH.)

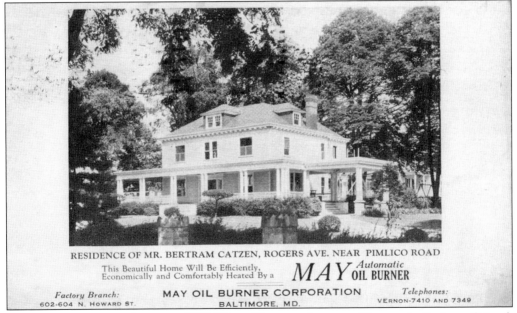

RESIDENCE OF MR. BERTRAM CATZEN, ROGERS AVE. NEAR PIMLICO ROAD

This Beautiful Home Will Be Efficiently, Economically and Comfortably Heated By a *MAY* Automatic OIL BURNER

Factory Branch: 602-604 N. HOWARD ST. | MAY OIL BURNER CORPORATION BALTIMORE, MD. | Telephones: VERNON-7410 AND 7349

HOME OF BERTRAM CATZEN, 2502 WEST ROGERS AVENUE (PIMLICO). Bertram Catzen's home was featured on this advertisement postcard for the May Oil Burner Corporation. U.S. Census records show that the Catzen family lived here in 1930. His occupation is listed as "box manufacturing." Catzen (born 1894) lived here with his wife, Hortense, and their two sons Dudley and Robert. The Catzens' also had three live-in servants, all girls from Germany, in the positions of maid, cook, and nanny. The house was razed during a Pimlico Racetrack expansion. (WH.)

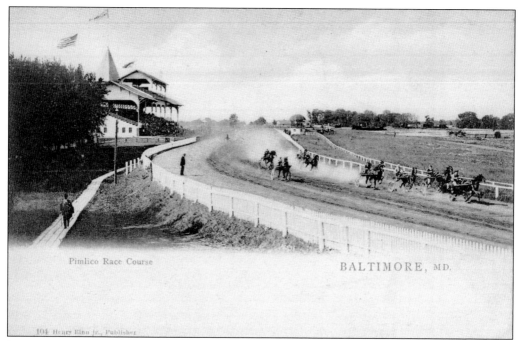

Pimlico Race Course

BALTIMORE, MD.

104 Henry Kinn jr., Publisher

PIMLICO RACE COURSE AND GENTLEMEN'S DRIVING PARK (PIMLICO). In 1851, the Maryland Agricultural and Mechanical Association purchased the estate known as Pimlico. The association had previously owned a fairground in modern-day Charles Village, but the site proved to be too small for the growing Maryland State Fair. In 1870, the Maryland Jockey Club leased the grounds from the association. The club erected the Steamboat Gothic clubhouse in 1873 that remained an icon until destroyed by fire in 1966. The track first opened its doors on October 25, 1870, making it the second oldest racetrack in the nation behind Saratoga. The Preakness Race runs here every year. Alfred G. Vanderbilt once observed, "Pimlico is more than a dirt track bounded by four streets. It is an accepted American institution, devoted to the best interests of a great sport, graced by time, respected for its honorable past." (WH.)

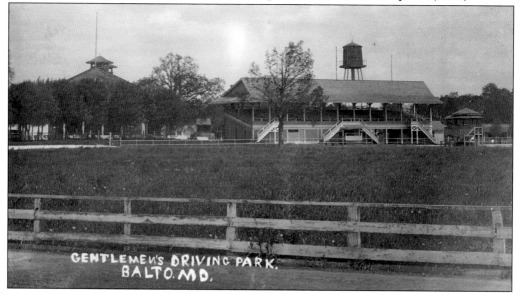

GENTLEMEN'S DRIVING PARK.
BALTO. MD.

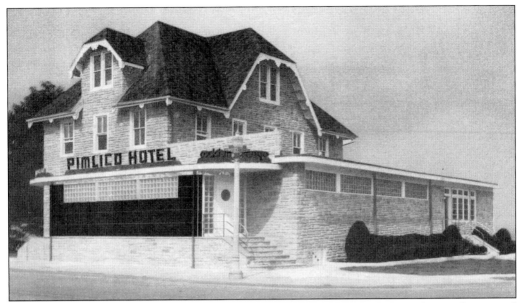

PIMLICO HOTEL, 5301 PARK HEIGHTS AVENUE, C. 1951 (PIMLICO). The Pimlico Hotel was built in 1875 and originally stood on the racetrack's infield. The building was moved about 1900 to the Park Heights Avenue location depicted on this postcard. The hotel was frequently raided during the Prohibition years. In 1951, the hotel was purchased by Leon Shavitz and renovated. He was most likely responsible for the Formstone hiding the Gothic architecture. The restaurant moved in 1981 and is no longer in business. This building has been demolished. (WH.)

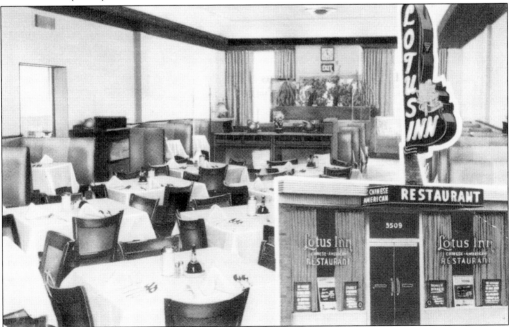

THE LOTUS INN, 5509 REISTERSTOWN ROAD (WOODMERE). The reverse of this postcard reads, "Maryland's finest Chinese & American restaurant. 5509 Reisterstown Rd., Md US Rt. 140, Baltimore 15, Maryland. Mo Hawk 4-5072." The building has since been razed. (WH.)

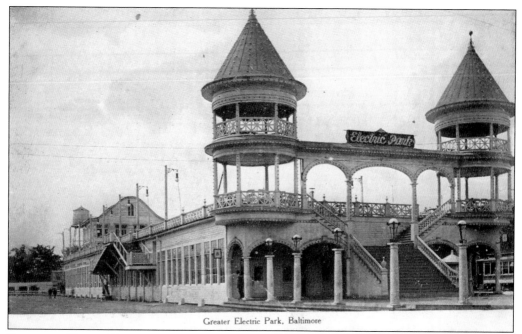

Greater Electric Park, Baltimore

ELECTRIC PARK, BELVEDERE AVENUE NEAR REISTERSTOWN ROAD (WOODMERE). The Electric Park opened in the 1890s. The main attraction was not the rides; it was the thousands of lights lining the building. Electricity was still a wonder to the many visitors. Some of the rides featured were the carousel, Shoot the Chute, Ferris wheel, Human Roulette Wheel, and the Johnstown Flood. The latter re-created the infamous flood in 1889 by storming a miniature of the town. The harness racing track can be seen in the foreground of the card below. In 1908, a dirigible was launched from the park, a first for Baltimore. The park was demolished in 1916. (WH.)

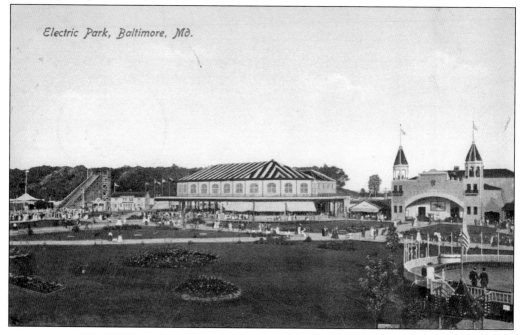

Electric Park, Baltimore, Md.

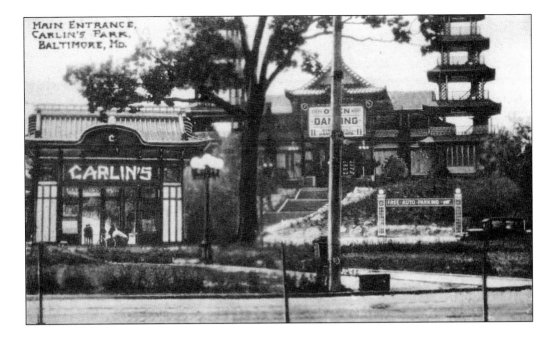

CARLIN'S PARK (PARK CIRCLE). Carlin's Park opened in 1919 under the name Liberty Heights Park. Owner John Carlin decided the park needed a shorter name and renamed the park after himself. The park had a Japanese theme that was carried throughout the park's architecture. Some of the attractions at the park included the Aero Swing, Mountain Speedway, and the Whip. The most famous visitor to the park was Rudolph Valentino, who participated in a dance competition in the Dance Palace. The park operated until the 1950s, when it was closed and later converted into Carlin's Drive-In Theatre, the only drive-in within the Baltimore City limits. The drive-in closed down by the 1970s, and the site is a mix of industrial and businesses today located on Carlin's Park Drive. (WH.)

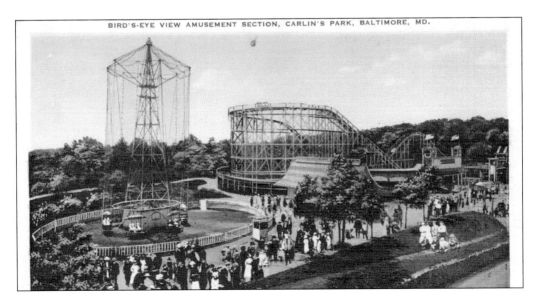

117

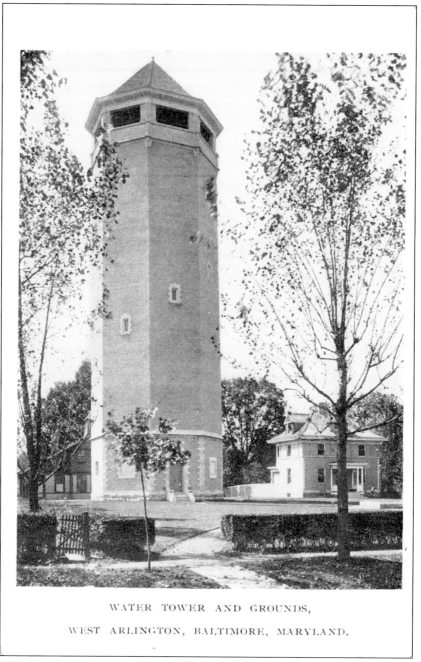

WATER TOWER AND GROUNDS,

WEST ARLINGTON, BALTIMORE, MARYLAND.

WEST ARLINGTON WATER TOWER AND GROUNDS, 4300 GRANADA AVENUE, C. 1907 (WEST ARLINGTON). In 1880, the community of West Arlington was the brainchild of George E. Webb, a Baltimore streetcar and real estate entrepreneur, who was later active in the development of the Mount Washington and Glen communities. The developer laid out several unpaved avenues and sold building lots. Development was slow at first but picked up toward the close of the 19th century. West Arlington's most distinctive landmark, the old octagonal water tower still standing, was built during the years 1897–1899 to provide water exclusively to this community. (WH.)

Nine

THE CENTER

BOLTON HILL, EUTAW PLACE, MIDTOWN, MOUNT VERNON PLACE, RESERVOIR HILL

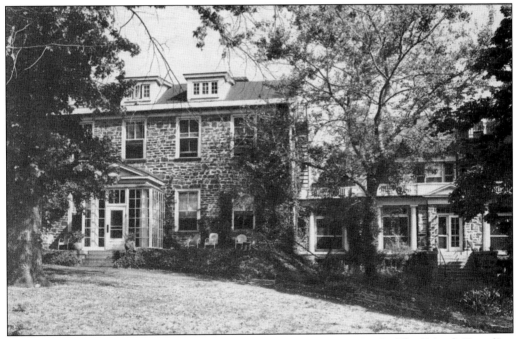

FRIENDS BOARDING HOUSE, 2001 PARK AVENUE (BOLTON HILL). The Friends Boarding House was built around 1792 as Mount Royal, the summer home of Dr. Solomon Birckhead. The boardinghouse was established in 1924 as a home for elderly members of Baltimore Monthly Meeting, Society of Friends, under the wills of Jonathan K. and Emma L. Taylor. In 1926, an addition was built with a bequest from Joseph C. Townsend. Later it was the Norwegian Seamen's Home from 1958 to 1966 and in 1977 opened as a city multipurpose center. (WH.)

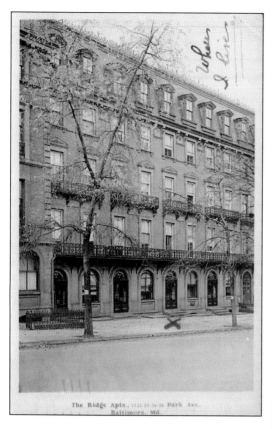

THE RIDGE APARTMENTS, 1522–1528 PARK AVENUE, C. 1929 (BOLTON HILL). In 1869, the now four brownstones were built as one structure known as Beethoven Terrace. The first known occupant was Daniel Bayne, a wholesale grocer. John F. Baugher (1832–1901), an educator, resided there around 1891 and opened the Winchester School for girls in 1894. By 1910, it was divided into five units known as the Ridge Apartments. It is known again today as the Beethoven Terrace. (WH.)

2411 LINDEN AVENUE, C. 1913 (BOLTON HILL). This 3,500-square-foot home with mansard roof was built in 1909. Its first occupants were August and Marie Roeder. It remains a private residence today. (WH.)

120

MARYLAND INSTITUTE COLLEGE OF ART ENTRANCE HALL, 1300 MOUNT ROYAL AVENUE, C. 1910 (BOLTON HILL). The Maryland Institute College of Art was founded in 1824 as the Maryland Institute for the Promotion of the Mechanic Arts in the Athenaeum on St. Paul Street. After more than one fire displaced the institute, the current school was built on Mount Royal Avenue in 1907, designed by the architectural firm of Pell and Corbett (www.mica.edu). (WH.)

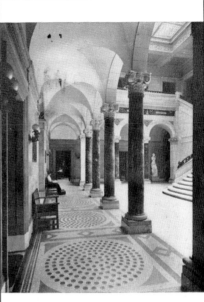

MARYLAND INSTITUTE ENTRANCE HALL
PELL & CORBETT
ARCHITECTS

WATSON MONUMENT, MOUNT ROYAL AVENUE AND HOWARD STREET, C. 1907 (BOLTON HILL). In 1903, a monument was erected in honor of Lt. Col. William H. Watson (1805–1846) by the Maryland Association of Veterans of the Mexican War. Watson, a Baltimorean and lawyer by trade, commanded the Baltimore Battalion and was killed in the battle of Monterey, Mexico. The monument also lists other Baltimoreans who fought in the Mexican War. Due to construction, the monument was moved in 1930 to Mount Royal and North Avenues. Edward Berge was the sculptor. (WH.)

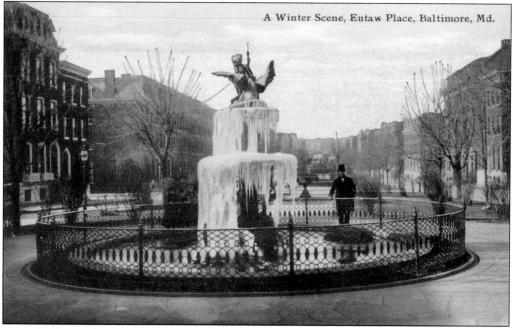

A Winter Scene, Eutaw Place, Baltimore, Md.

EUTAW PLACE WINTER SCENE, C. 1911 (EUTAW PLACE). Eutaw Place is named after the Revolutionary War battle of Eutaw Springs. In 1853, Henry Tiffany donated land to serve as a series of public squares along the center of Eutaw Street. (WH.)

THE MANSION—1739 EUTAW PLACE

BALTIMORE'S FINEST GUEST HOUSE
(TURN OVER)

THE MANSION GUEST HOUSE, 1739 EUTAW PLACE (EUTAW PLACE). The mansion was originally built as a private residence, around 1905, for department store magnate Albert A. Brager (1859–1936). The home was designed by Charles M. Anderson. The Brager family lived there until about 1921. By 1933, the house was owned by Charles E. Sigmund. From 1935 to 1937, it was the headquarters of the Bachelor's Club. Today the mansion has been divided into apartments. (WH.)

FRANCIS SCOTT KEY MONUMENT, EUTAW PLACE AT LANVALE STREET (EUTAW PLACE).
The Francis Scott Key (1780–1843) monument and fountain was erected in 1911. The monument was a gift of Charles L. Marburg, head of the Marburg Brothers tobacco firm. Marburg, who died in 1907, established the Municipal Art Society in 1896 and believed monuments were a way to achieve the "City Beautiful." It was sculpted by Frenchman Jean Marius Antonin Mercie. The monument represents Key returning from his detainment by the British with his manuscript that would later become the national anthem. (WH.)

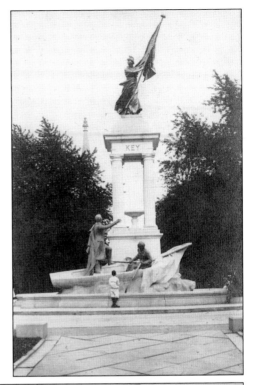

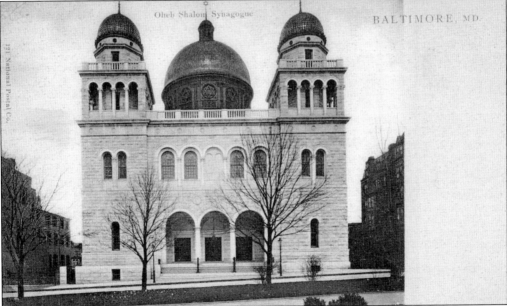

OHEB SHALOM SYNAGOGUE, 1301 EUTAW PLACE (EUTAW PLACE). Oheb Shalom Synagogue was established in 1853 and originally located on Hanover Street near present-day Camden Yards. In 1892, the congregation built the synagogue depicted here. It was modeled after the Great Synagogue of Florence, Italy. In 1953, the present site in Pikesville was acquired and the synagogue moved to Park Heights Avenue in 1960. Today it is owned by the Most Worshipful Prince Hall Grand Lodge and the Accepted and Free Masons. (WH.)

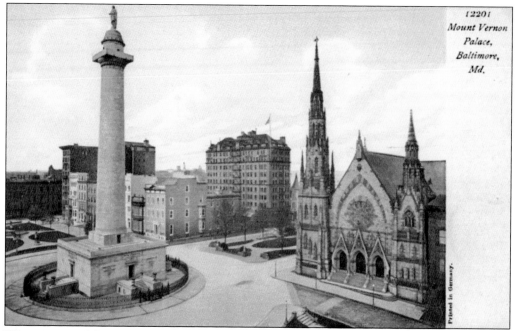

WASHINGTON MONUMENT, MOUNT VERNON PLACE (MOUNT VERNON PLACE). In 1815, construction began on a statue designed by Robert Mills, who also designed the Washington Monument in Washington. It was completed by 1829. The monument to George Washington was the first architectural monument planned in his honor. The monument is referenced by Herman Melville in his book *Moby-Dick*: "Great Washington, too, stands high aloft on his towering main-mast in Baltimore, and like one of Hercules' pillars, his column marks that point of human grandeur beyond which few mortals will go." (WH.)

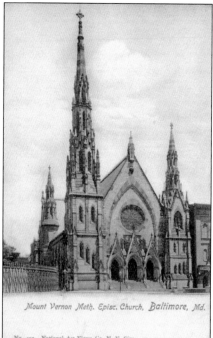

Mount Vernon Meth. Episc. Church, Baltimore, Md.

No. 202. National Art Views Co. N. Y. City

MOUNT VERNON PLACE UNITED METHODIST CHURCH, 10 EAST MOUNT VERNON PLACE (MOUNT VERNON PLACE). Mount Vernon Place United Methodist Church was conceived of as a "Cathedral of Methodism." The building was designed by Thomas Dixon and Charles L. Carson and completed on November 12, 1872, in what was then the outskirts of the city. The church sits on the site of the mansion of Charles Howard, who was married to Elizabeth Phoebe Key. Her father, Francis Scott Key, the author of "The Star Spangled Banner," died here in his daughter's home (www.gbgm-umc.org). (WH.)

**THE GEORGE PEABODY INSTITUTE
LIBRARY, 17 EAST MOUNT VERNON PLACE
(MOUNT VERNON PLACE).** The George
Peabody Library, formerly the Library of the
Peabody Institute of the City of Baltimore,
was opened in 1878. George Peabody,
a Massachusetts-born philanthropist,
dedicated the Peabody Institute to the
citizens of Baltimore in appreciation of their
"kindness and hospitality." The Peabody
Institute originally comprised a free public
library, a lecture series, a conservatory
of music, and an art collection. It was
designed by Baltimore architect Edmund
G. Lind. The institute is now a division
of the Johns Hopkins University (www.
peabodyevents.library.jhu.edu). (WH.)

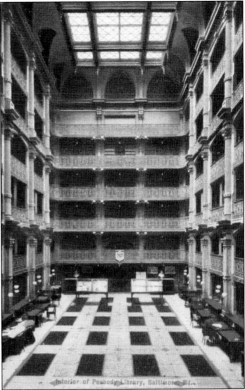

Interior of Peabody Library, Baltimore, Md.

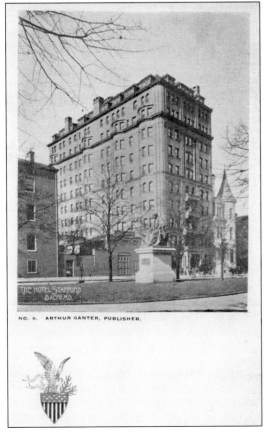

THE HOTEL STAFFORD
BALTO. MD.

NO. 9. ARTHUR GANTER, PUBLISHER.

**THE STAFFORD HOTEL, 714 NORTH
CHARLES STREET (MOUNT VERNON
PLACE).** Erected in 1894, the Stafford
Hotel's welcome to Mount Vernon
Place was lukewarm at best. Many
residents did not want something as
common as a hotel in their midst. The
10-story hotel was designed by Charles
Caswell in the popular Beaux-Arts style
of his time. Today the Stafford serves
as an apartment building. (WH.)

Deutsches Haus
Baltimore, Md.

Ed. Althausen.

DETUSCHES HAUS, 1212 CATHEDRAL STREET (MIDTOWN). In 1885, the land on which the Detusches Haus was built was purchased by Mary Elizabeth Garrett as the first home of the Bryn Mawr School for Girls. It had the first school gymnasium for girls in the United States. The architect was Henry Rutgers Marshall. In 1933, the building was sold to the Baltimore Sangerbund, a consortium of local German cultural groups. By the 1940s, all things German were frowned upon and the memberships dwindled. It was demolished in 1973 and is the current site of the Meyerhoff Symphony Hall. (WH.)

DUCHESS OF WINDSOR'S GIRLHOOD HOME
212 E. BIDDLE St. BALTIMORE, MD.

THE GIRLHOOD HOME OF THE DUCHESS OF WINDSOR, 212 EAST BIDDLE STREET (MIDTOWN). This was the childhood home of Bessie Wallis Warfield (1896–1986), better known as the Duchess of Windsor. She was the infamous twice-divorced woman to capture the heart of King Edward VIII, Prince of Wales, who abdicated the throne to marry her. She lived in this house from 1896 until 1901, moving from Pennsylvania after the death of her father. (WH.)

HOME OF GEORGE AND MOLLIE E. SHELTON, 2545 MADISON AVENUE, C. 1907 (RESERVOIR HILL). The 1910 U.S. Census lists George, a furniture salesman, and his wife, Mollie, at this address. Also living here is their live-in servant Ada Jervers and her nine-year-old daughter Emily. Today the 2500 block of Madison Avenue looks very much the same. (WH.)

Discover Thousands of Local History Books Featuring Millions of Vintage Images

Arcadia Publishing, the leading local history publisher in the United States, is committed to making history accessible and meaningful through publishing books that celebrate and preserve the heritage of America's people and places.

Find more books like this at
www.arcadiapublishing.com

Search for your hometown history, your old stomping grounds, and even your favorite sports team.

Consistent with our mission to preserve history on a local level, this book was printed in South Carolina on American-made paper and manufactured entirely in the United States. Products carrying the accredited Forest Stewardship Council (FSC) label are printed on 100 percent FSC-certified paper.

MADE IN THE USA